The Public Library

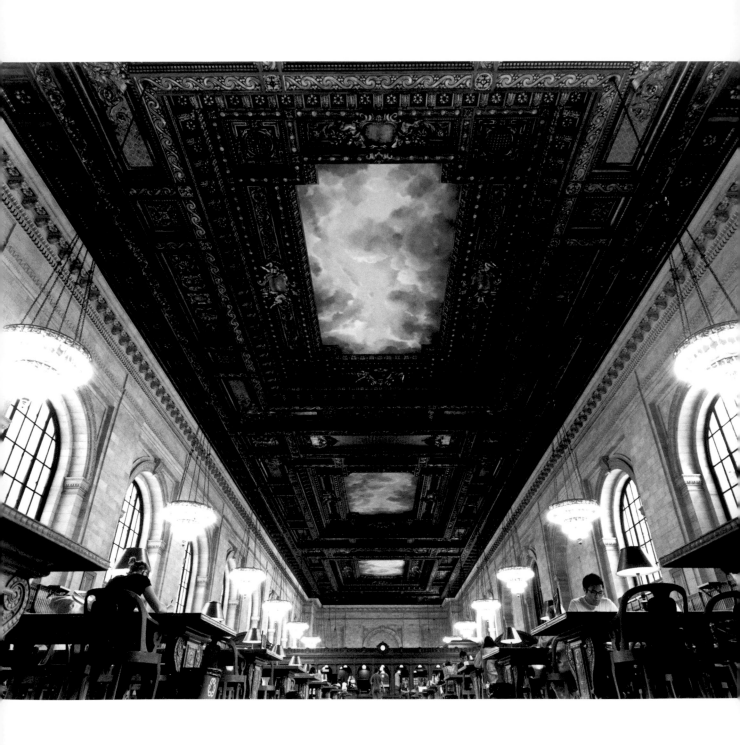

The Public Library

A PHOTOGRAPHIC ESSAY BY
Robert Dawson

foreword by **Bill Moyers** afterword by **Ann Patchett**

with reflections by **Isaac Asimov** · **Barbara Kingsolver** · **Anne Lamott** · **Philip Levine** ·
Dr. Seuss · **Charles Simic** · **Amy Tan** · **E. B. White** · **and others**

PRINCETON ARCHITECTURAL PRESS

NEW YORK

previous

Reading room, Stephen A. Schwarzman Building, New York Public Library, New York, New York, 2008 | Often referred to as the "main branch," this Beaux-Arts landmark was initially formed from the consolidation of the Astor and Lenox Libraries and has evolved into one of the world's preeminent public libraries. It houses some fifteen million items, including priceless medieval manuscripts, maps, and contemporary novels and poetry, as well as baseball cards, dime novels, and comic books. More than twelve hundred languages and dialects, ancient and modern, are represented in the collections, emblematic of the rich diversity of the city that built it.

Published by
Princeton Architectural Press
37 East Seventh Street
New York, New York 10003

Visit our website at www.papress.com

Editors: Sara Stemen and Sara Bader
Designer: Paul Wagner

Special thanks to:
Meredith Baber, Nicola Bednarek Brower, Janet Behning, Megan Carey, Carina Cha, Andrea Chlad, Barbara Darko, Benjamin English, Russell Fernandez, Will Foster, Jan Hartman, Jan Haux, Diane Levinson, Jennifer Lippert, Katharine Myers, Lauren Palmer, Jay Sacher, Rob Shaeffer, Andrew Stepanian, and Joseph Weston of Princeton Architectural Press
—Kevin C. Lippert, publisher

GRAHAM FOUNDATION

This project was supported by a generous grant from the Graham Foundation for Advanced Studies in the Fine Arts.

Library of Congress Cataloging-in-Publication Data
The public library : a photographic essay / Robert Dawson ; foreword by Bill Moyers ; afterword by Ann Patchett. — First edition.
 pages cm
Includes essays, letters, and poetry by a collection of American writers and librarians.
ISBN 978-1-61689-217-3 (hardback)
1. Public libraries—United States—Pictorial works.
2. Public libraries—United States. 3. Libraries and society—United States. 4. Libraries and community—United States. 5. Library users—United States.
I. Dawson, Robert, 1950- Photographs. Selections.
Z731.P9265 2014
027.70973—dc23
 2013026827

CONTENTS

FOREWORD · BILL MOYERS

In a file next to my desk, I have kept for fifteen years a now-yellowed clipping from the weekly newspaper in the small town in New Jersey where we live. The headline reads: "LIBRARY WAS TOP BERNARDSVILLE STORY IN '98." Yes, the biggest news of the year was the construction of a municipal library in the center of town at a cost of almost $5 million. I have kept the story because as a citizen and journalist, I never want to forget what really matters—and the local library matters.

Fast-forward to 2011. We were hit hard by the Halloween snowstorm that knocked out power over a wide area of central New Jersey. The next day—a cold and dark Sunday— our library became a refuge to nearly one thousand people who warmed themselves, recharged their technological and personal batteries, and discovered camaraderie born of adversity. The library mattered for reasons we had not anticipated.

The library mattered, too, in the small Texas town where I grew up. Lady Bird Johnson and I once served as cochairs of the campaign to build it. Long before she became Mrs. Lyndon B. Johnson and America's first lady, she had graduated from high school there, as I would later. She liked to recall that in her time, the municipal library consisted of a modest collection of randomly donated books stored in a cramped and darkly lit space under the stairs in the county courthouse. By the time I came along, a group of businesswomen had managed to acquire a lovely Georgian building between the business district and the First Baptist Church and turn it into a free library that became a mecca for poor kids like me. There, at the age of eleven or twelve, I entered a boundless world to discover more lives to lead than I had dreamed of. In books plucked from the shelves were stories that I have never forgotten: explorers whose adventures I could envy, heroes whose exploits I could admire, villains I could hiss.

I still remember the first two books I took home: Jules Verne's *Around the World in Eighty Days* and a popular version of ancient Greek and Roman myths whose title now escapes me. I do not know why I chose those two, but when I won third prize in a tenth-grade poetry contest with a pretentious little lyric entitled "I Have Seen Rome," some classmates ribbed me about how I could possibly know of Colosseums and catacombs and caesars in togas. I knew how: the Appian Way began for me on East Burleson Street

in that small Texas town. Years later, when I visited Rome as a graduate student, I was struck by how familiar it seemed, although I had never been there. Samuel Beckett was right: when we are reading, a voice comes to us as in the dark and whispers, "Imagine!"

Of course, books and reading, periodicals and references no longer exhaust the definition of a library. The one in the town where I live is a beehive of activity. The year of the storm, there were 200,046 visits, an average of 25 per resident; 161,945 people used the website; 78,870 accessed its computers; 14,384 children attended "story time," and the library conducted a tech update on cloud storage, a session on how citizens could protect against financial fraud, a screening of the documentary *Forks Over Knives* (the film Roger Ebert said "could save your life"), an art exhibit, book discussions, and a Sunday jazz concert, among many other events—all for a base budget of just one million dollars.

Libraries come in all shapes and sizes, as Robert Dawson stunningly reminds us in this collection of photographs. He takes us to different places and different libraries, one by one, for a glimpse into what he aptly calls "a vibrant, essential, yet threatened system" that has contributed immeasurably to the fiber and fabric of our democracy.

In these pages you will travel through America, past and present, from the grandeur of the reading room in the main library in New York City to the layered Victorian solidity of the Willard Library in Evansville, Indiana, from the spare, trailer-like library in Death Valley National Park to the Star Trek–like gleaming latticed wonder of the central library in Seattle, Washington. You will quickly realize the pleasures of a journey across a vital commons of the American experience in the company of an accomplished artist whose work has graced the Museum of Modern Art in New York, the J. Paul Getty Museum in Los Angeles, and the Library of Congress in Washington, D.C.

Open the book to page 116. You are now on the ground floor of the library in Midland, Texas—far out on the plains of the Lone Star State. Look to the left. There in the corner you will see a room marked "Children." Now look to your right: a solitary young man, attired in a T-shirt, shorts, and sandals, sits intently engaged. Let your eyes follow the stairs upward. Notice the directions to the left: "Nonfiction/ Reading Room/Reference." To the right: "Business/ Meeting Room/Periodicals." The photograph is memorably framed to reveal converging worlds beneath a single roof.

Now turn to page 19 and the gallery of rapt onliners in the computer room of the Harold Washington Library Center in Chicago. Studying the myriad faces, I wondered how many hopes and dreams ride on each cursor and click? On page 18 the Tulare County Free Library in Allensworth, California, requires a lingering visit as you consider the former slaves who built it and who only decades before would likely have been punished if caught reading the books that went into it—one of those contradictions in American history that haunts us to this day. Yet on page 71 you will come to the library in Mississippi named for Fannie Lou Hamer, the ejected tenant farmer who refused to be intimidated and became a heroine of the civil rights movement.

Eighteen years in the making, this new and stunning collection could not have come at a more propitious time. The library is being reinvented in response to the explosion of information and knowledge, promiscuous budget cuts in the name of austerity, new technology, and changing needs. Who knows where the emerging new commons will take us? But Robert Dawson shows us in this collection what is at stake: when a library is open, no matter its size or shape, democracy is open, too.

INTRODUCTION

The very existence of libraries affords the best evidence that we may yet have hope for the future of man.
—T. S. Eliot

I have always imagined that Paradise will be a kind of library.
—Jorge Luis Borges

As a child, I was addicted to television. Mine was the first generation raised on TV, and I remember learning when to run home to see my favorite program by the position of the sun in the sky. But eventually world events, school, music, sports, and friends became far more interesting than the flickering tube. Even as a teenager I could see the importance of books as a way to explore the world, compared to the vast wasteland of commercial television. (Groucho Marx once said, "I must say I find television very educational. The minute somebody turns it on, I go to the library and read a good book.") Books have always kept my interest partly because they allowed me to escape the mundane existence of my life in West Sacramento into something far more exciting and engaging. They showed me a way to something better.

Oprah Winfrey described the importance of books and libraries in her childhood:

> As a young girl in Mississippi, I had big dreams at a time when being a Negro child you weren't supposed to dream big. I dreamed anyway. Books did that for me.... For me,

those dreams started when I heard the stories of my rich heritage. When I read about Sojourner Truth and Harriet Tubman and Mary McLeod Bethune and Frederick Douglass, I knew that there was possibility for me. [1]

Isaac Asimov told a similar story about his life:

> My *real* education, the superstructure, the details, the true architecture, I got out of the public library. For an impoverished child whose family could not afford to buy books, the library was the open door to wonder and achievement, and I can never be sufficiently grateful that I had the wit to charge through that door and make the most of it. [2]

The importance of books and libraries is echoed as well in the life of Malcolm X. He learned many important lessons on the street, but felt that his real education came from books. "My alma mater was books, a good library. I could spend the rest of my life reading, just satisfying my curiosity." Winfrey, Asimov, and Malcolm X all came from impoverished backgrounds and used the library to escape

and to discover a wider world. For countless people the public library represents opportunity and hope.

Even in our Internet era, more books are being published than ever before, yet library budgets are shrinking. More is being demanded of our libraries, as they move beyond their role as centers for books and knowledge to becoming centers for community. The homeless often find the library to be one of the few safe havens available to them. (The San Francisco main library is unique in having a full-time social worker on staff to help direct patrons to more appropriate government assistance.) Libraries can function as shelters from extreme heat, freezing cold, and violence on the street. A librarian in Oakland explained to me recently, "Libraries are an essential community service. We do much more than lend DVDs, books, books on CD, and music. We literally save people's lives every day.... Public librarians are frontline workers for the poor and the disenfranchised, and advocates for the underserved all over the country."

During the Great Depression of the 1930s, record numbers of people used their local public libraries. After the economic collapse in 2008, libraries across the country similarly began seeing double-digit increases in patronage (often from 10 to 30 percent over previous years). According to the Institute of Museums and Library Services, "Public libraries circulated 2.46 billion materials in (fiscal year) 2010, the highest circulation in 10 years, representing a continued increasing trend." [3]

Sadly, libraries are also among the first to suffer severe cutbacks in funding as we debate the role of government in our country. Bob Herbert wrote in the *New York Times*:

Income and wealth inequality in the U.S. have reached stages that would make the third world blush....This inequality, in which an enormous segment of the population struggles while the fortunate few ride the gravy train, is a world-class recipe for social unrest. Downward mobility is an ever-shortening fuse leading to profound consequences. [4]

This was written before Occupy Wall Street dramatically brought the issue of rising income inequality in America to national attention. As that gap continues to widen, what is left for the 99 percent?

One thing is our magnificent national infrastructure of public roads, health care, courts, schools, and libraries. Built over many years, these essential resources are, sadly, being starved into oblivion. In the nineteenth century there was a strong correlation between the public library movement and the movement for public education. Americans understood that the future of democracy is contingent on an educated citizenry. They also felt that every citizen should have the right of free access to community-owned resources. These ideas coalesced in the formation of today's public libraries, which function as a system of noncommercial centers that help us define what we value and what we share. In a culture that is increasingly privatized, libraries are among the last free spaces we have left. Public libraries are worth fighting for, and this book is my way of fighting.

During the Vietnam War, while I was in college, I photographed a particularly tense standoff between an angry group of antiwar activists and a group of local riot squad policemen. The activists held a huge banner proclaiming, "We Will Dance On Your Graves, Motherfuckers" and were screaming in rage at the police. The policemen wore identical black jumpsuits with helmets and face masks and were nervously slapping black nightsticks into their gloved hands. The tension was mounting to an unbearable level, and we all knew something dramatic was about to happen. Just then a young, skinny, barefoot guy dressed as a Hare Krishna started dancing down the middle of the street. With long locks of hair falling from his mostly shaved head and little cymbals in his hands, he slowly sang and danced the length of the street between the two opposing sides who had been preparing to fight. It changed everything. It was an astonishing demonstration of audacity and courage. It reframed the tense standoff and averted a bloody battle. Today, as the rich get richer and the rest of us get poorer, I am inspired by that crazy kid chanting a shaky song.

I know that libraries can help level the playing field. I have seen it in my own life and throughout the country during my eighteen years of photographing public libraries. Like that young Hare Krishna man from long ago, I hope that my own contribution can help reframe our often-bitter debate on the American Dream.

THE PROJECT

The idea for this project came out of a conversation with photographer Brian Grogan and my wife, Ellen Manchester. Ellen and I had been directing for years a large-scale collaborative photographic project called Water in the West, which looked at the shared resource of water in the arid American West. The book *Court House*, edited by Richard Pare, also inspired us. It was a photographic survey of the county courthouse system throughout the United States that explored the critical importance of this system in American government and society. Since coming of age during the Vietnam War, I have been interested in the things that help bind us together as a culture. It wasn't much of a leap from my interest in water in the West to the shared commons of public libraries.

This project has also been inspired by the long history of photographic survey projects. The first was undertaken in 1851, when the French government commissioned five photographers to make images for the Mission Héliographique, as a study of French architectural patrimony. In the latter part of the nineteenth century, the United States government sent photographers on some of the great geological surveys of the American West. My wife, Ellen, along with Mark Klett, JoAnn Verburg, and others, would rephotograph many of these sites in the late 1970s, producing a book called *Second View* in 1984, another inspiration for my library project. Finally, the United States government documented its recovery efforts during the Great Depression of the 1930s under the group that came to be called the Farm Security Administration. They hired some of the greatest documentary photographers of that era, including Walker Evans and Dorothea Lange. The FSA study is now regarded as one of the greatest of all photographic surveys. My project is very different from these efforts, but their national scope and ambition helped shape my own thinking.

THE LIBRARY ROAD TRIPS

Libraries are local, but I chose to view this system as a whole. There are approximately seventeen thousand public libraries in the United States. Since I began this project in 1994, I have photographed hundreds of libraries in forty-seven states.

I didn't intend this project to last eighteen years. Many of the early libraries were photographed during longer journeys, when I had the time. The photography was usually connected to some other effort, such as when I taught workshops in Alaska in 1994 and Key West, Florida, in 1997. In 2000 my family and I took a long drive throughout the American West, occasionally photographing libraries along the way. In 2007 we traveled through Louisiana and parts of the South, again photographing a few. Every summer we have stayed in a little cabin in Vermont. I have always brought my camera along on each of those trips and gradually began to accumulate photographs from places other than my home in California. In the late 2000s I began to focus the project. I made specific library photo trips throughout Nevada and to Seattle, Salt Lake City, and Chicago. I began to realize that if I wanted to make this a national study, I had some more traveling to do.

In the summer of 2011 my son Walker and I spent eight weeks driving more than 11,000 miles to 26 states, photographing 189 libraries. We drove through the Southwest; Texas; the South, including the Mississippi Delta; up to Detroit; through the Rust Belt; and then over to Washington, D.C.; Philadelphia; and New England. Unfortunately, we were followed the entire way by a record-breaking heat wave. We called it our Library Road Trip and even got it funded through a Kickstarter effort. Filmmaker Nick Neumann joined us during part of the trip. I would write during the day and in the evening post a blog with my writing, our photos, and some of Walker and

Nick's film footage. I would change my large-format 4×5 film in the motel bathroom while Nick and Walker edited the video that they had shot that day. The next morning we would get up and do it all over again. This odyssey was exhausting but solidified the project and its goals.

In the summer of 2012 Walker accompanied me again as we spent four weeks driving more than 10,000 miles to 15 states, photographing 110 libraries. As we drove we listened to two extraordinary books on tape—*A People's History of the United States* by Howard Zinn and *1491* by Charles C. Mann. Both helped provide a context for what we were seeing. We traveled throughout the upper Midwest and witnessed some of the devastating drought in the farm belt. I again posted our travels on our blog, *Library Road Trip* (libraryroadtrip.wordpress.com). The 2012 trip filled in the parts of the map that I had not previously photographed and largely completed the project. However, at the end of the summer, I realized that I had photographed many libraries in poor communities but not many in wealthy places. So to add balance I photographed libraries in some of the country's wealthiest communities near my home in the San Francisco Bay Area, including Mill Valley, Tiburon, and Portola Valley. Finally, in November 2012, I finished the project by photographing the heroic efforts of the Queens Public Library to provide services to the victims of Hurricane Sandy in the Rockaways in New York City.

Because I started the project shooting film, I continued to use film cameras throughout the project. The 4×5 Toyo Field camera was ideal for recording the details of public libraries. I would also use a medium-format Mamiya 7 camera when I didn't feel comfortable or have time to shoot with the larger-view camera. Over the last few years, I would also shoot recording shots with a small Canon G10 digital camera alongside the images made with my larger film cameras. Sometimes it was helpful to use this camera first, to locate the best angle or most interesting subjects in a library. I found the digital shots also useful to post on my blog.

AN AMERICAN COMMONS

In his 2013 State of the Union address, President Barack Obama said that citizenship "only works when we accept certain obligations to one another and to future generations." *New York Times* columnist Timothy Egan declared that the American "Great Experiment—the attempt to create a big, educated, multi-racial, multi-faith democracy that is not divided by oligarchical gaps between rich and poor—is still hanging in the balance." [5] Our national public library system goes a long way toward uniting these United States. A locally governed and tax-supported system that dispenses knowledge and information for everyone throughout the country at no cost to its patrons is an astonishing thing—a thread that weaves together our diverse and often fractious country. It is a shared commons of our ambitions, our dreams, our memories, our culture, and ourselves.

This project has allowed me a means of viewing much of our country over the last two decades. During that time libraries have changed dramatically, especially with the introduction of computers. However, since this nationwide odyssey, Walker and I have come to some similar conclusions: We Americans share more than what divides us. Most people work hard at their jobs and care about their families as well as their communities and the places they call home. And many care passionately about their libraries. Over the course of this project, I have been socked in the jaw by a crazed man in Braddock, Pennsylvania; screamed at by a homeless woman in Duluth, Minnesota; almost had my film confiscated on an Indian reservation in Colorado; and eyed suspiciously throughout the country. Despite all, this project has only reinforced my belief in the basic decency of most Americans. It has been a privilege to complete this study of our nation's public libraries. And it has been a rare opportunity to see what we have in common through the lens of the local public library.

Robert Dawson
April 2013, San Francisco, California

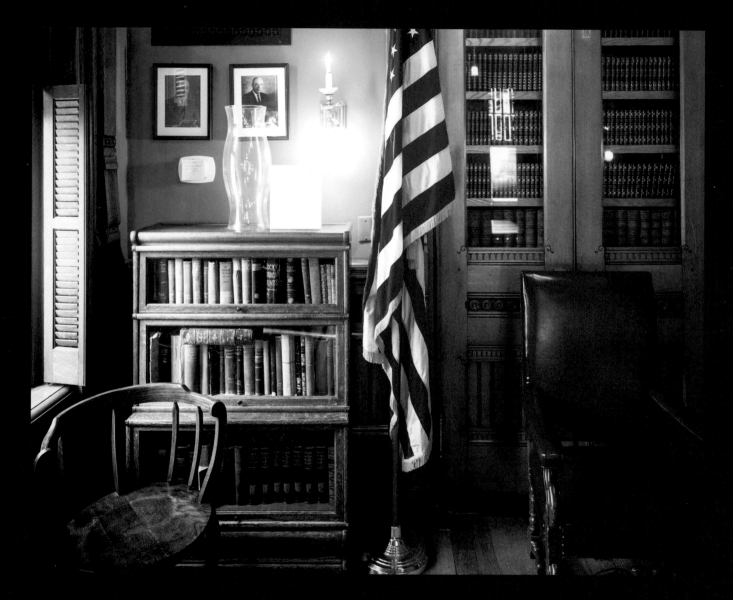

Interior, Willard Library, Evansville,
Indiana, 2011

THE AMERICAN PUBLIC LIBRARY

The photographs in this book are intended to be a broad study of public libraries in America over an eighteen-year period. There are approximately seventeen thousand public libraries in the United States, and I tried to include the broadest range of them possible. My photographs capture some of the poorest and wealthiest, oldest and newest, most crowded and most isolated, even abandoned, libraries.

This chapter presents an overview of my nationwide survey, made during a time when this dynamic system was experiencing a profound change in its identity and purpose. I have always thought of public libraries as beacons of hope, and it saddened me each time I came upon a library that had been destroyed, either through natural disaster, neglect, or local economic collapse.

The concept of the public library originated in many places. The world's first tax-supported public library was founded in Peterborough, New Hampshire, in 1833. Other types of libraries predated and followed this milestone, eventually forming our contemporary system of publicly financed, community-owned libraries. Throughout the long history of public libraries in America, they have showed us a way to something better. What would we become as a nation without them?

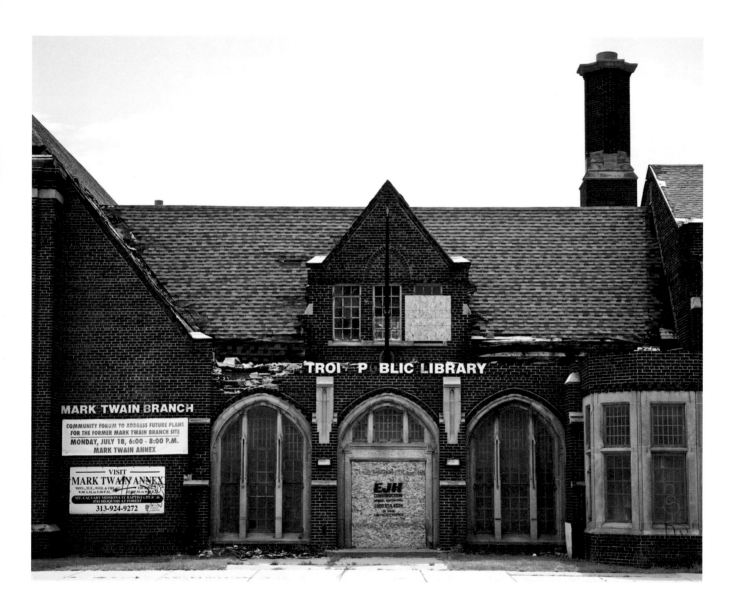

**Destroyed Mark Twain Branch Library, Detroit,
Michigan, 2011**

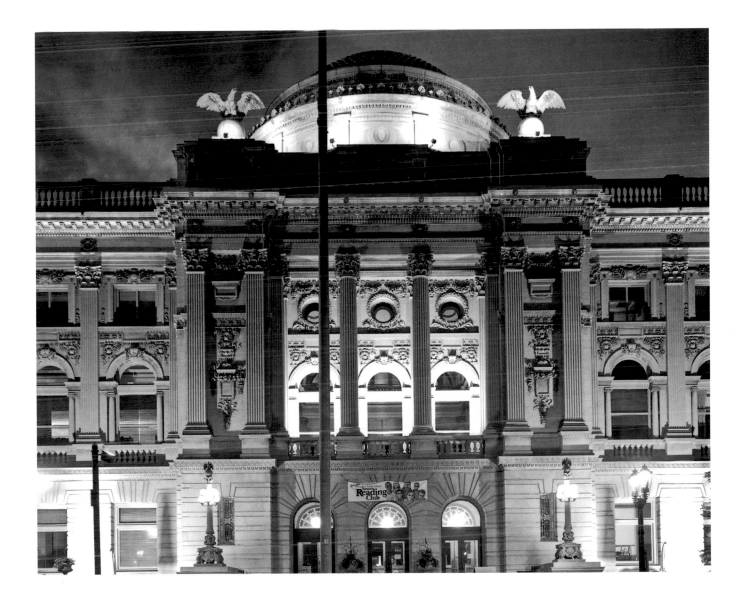

Central Library, Milwaukee, Wisconsin, 2012

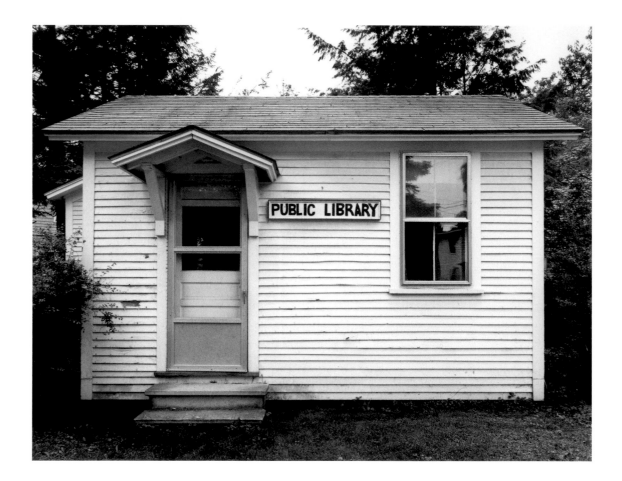

**The nation's smallest library (now closed),
Hartland Four Corners, Vermont, 1994** |
This library was assembled from two office rooms
of a local sawmill in 1944. It had no heat except
for a wood-burning stove. It once claimed to be
"the smallest library in the nation," a title claimed
by several other libraries. At the time I made this
photograph, its entire collection of seventy boxes
of books had just been sold to a local used-book
dealer for $125.

opposite
**Central Library, Seattle, Washington,
2009** | Dutch architect Rem Koolhaas and Joshua
Ramus were principal designers for this library that
opened in 2004.

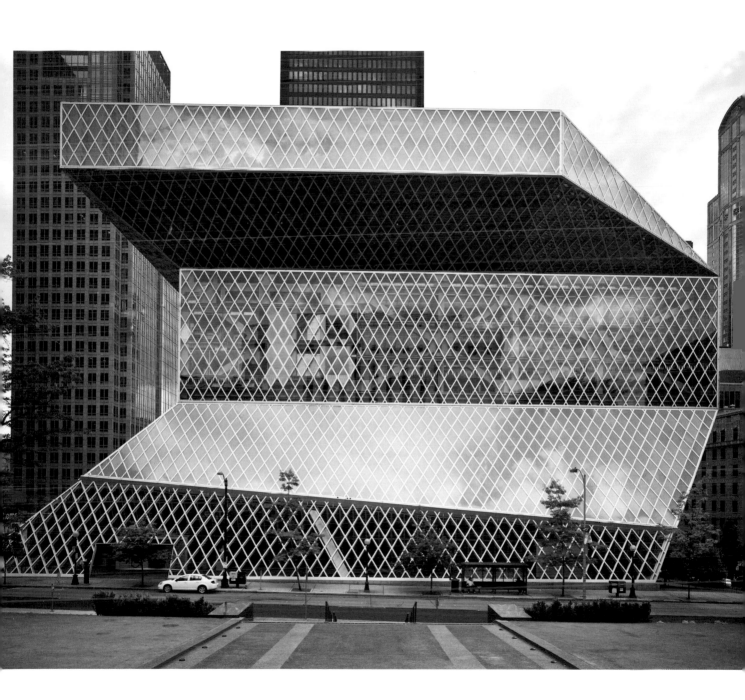

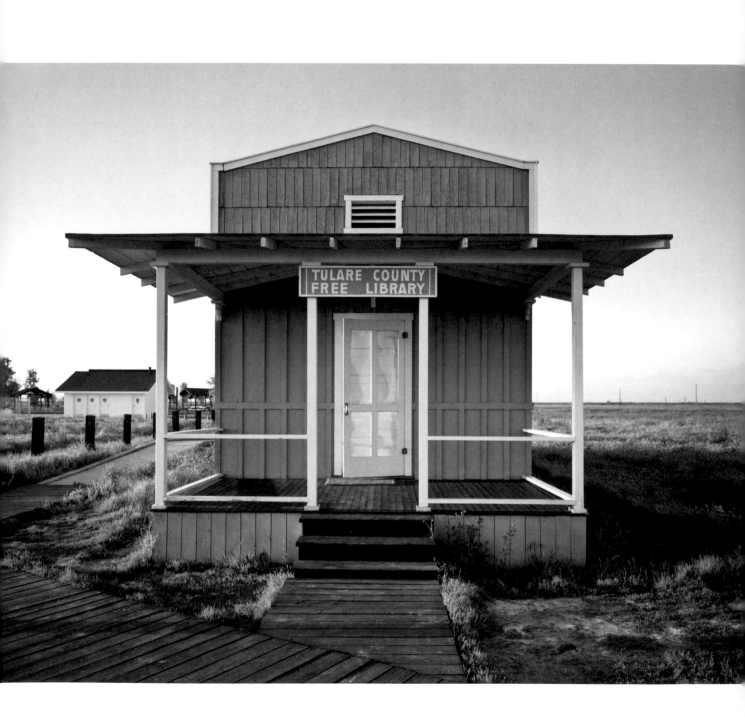

THE PUBLIC LIBRARY

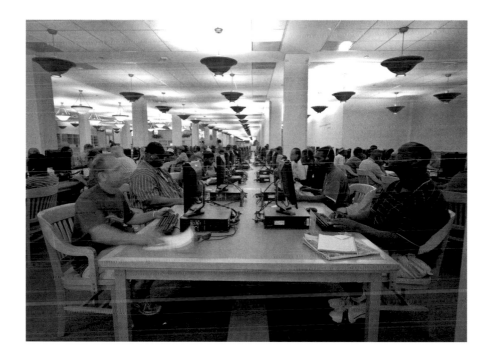

opposite

Library built by ex-slaves, Allensworth, California, 1995 | Allen Allensworth began his remarkable life as a slave in Kentucky in 1842. He later became a petty officer in the US Navy, a Baptist minister, and a chaplain in the US Army. He founded the California Colony of Allensworth, which existed for several years during the early part of the twentieth century in Tulare County. The library is a re-creation of the original, in what is now called Col. Allensworth State Historic Park.

above

Computer room, Harold Washington Library Center, Chicago, Illinois, 2009 | Computers have become essential in any library, as many government and business forms are now eforms. Libraries are also among the few places people can take free classes on how to use computers and other technologies. Especially for poor people, access to free computers in libraries is necessary to function into today's wired world. Libraries have always adapted to new technology, whether by offering records and videotapes decades ago, or ebooks and computer terminals today. According to Neil Steinberg of the *Chicago Sun-Times*, "The Chicago Public Library offers 2,500 public computer terminals, which is the most available free in the city."[6]

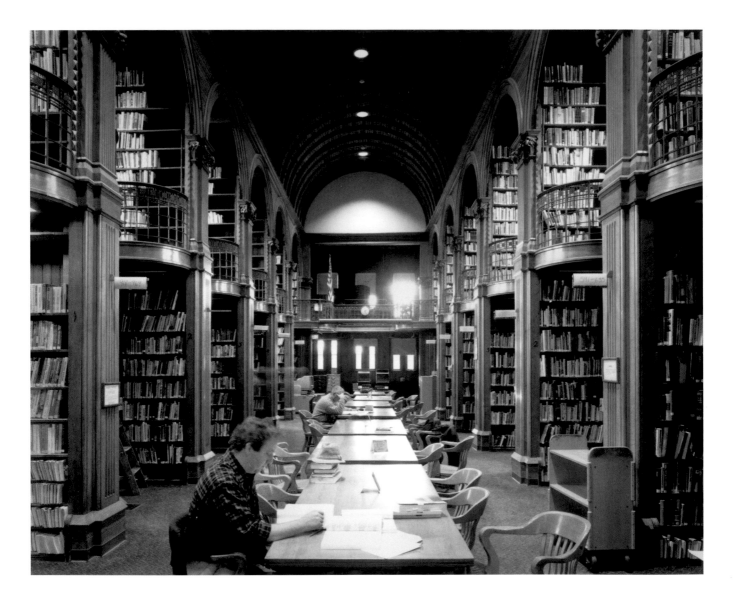

Reading room, Woburn Public Library, Woburn, Massachusetts, 1994 | After a large bequest by Charles Winn to the town of Woburn in 1876, the famed American architect Henry Hobson Richardson was selected to design his first library. The Woburn Public Library is now a National Historic Landmark.

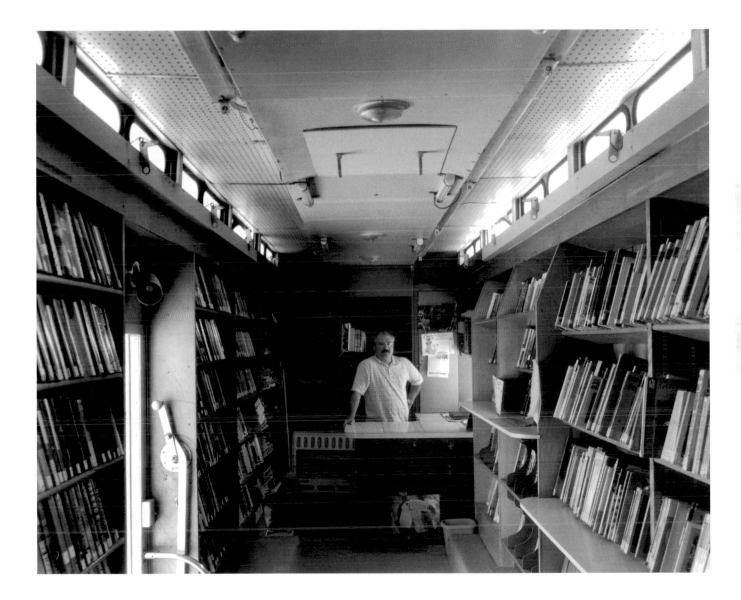

Northeastern Nevada Regional
Bookmobile Librarian, Elko County Library,
Baker, Nevada, 2000

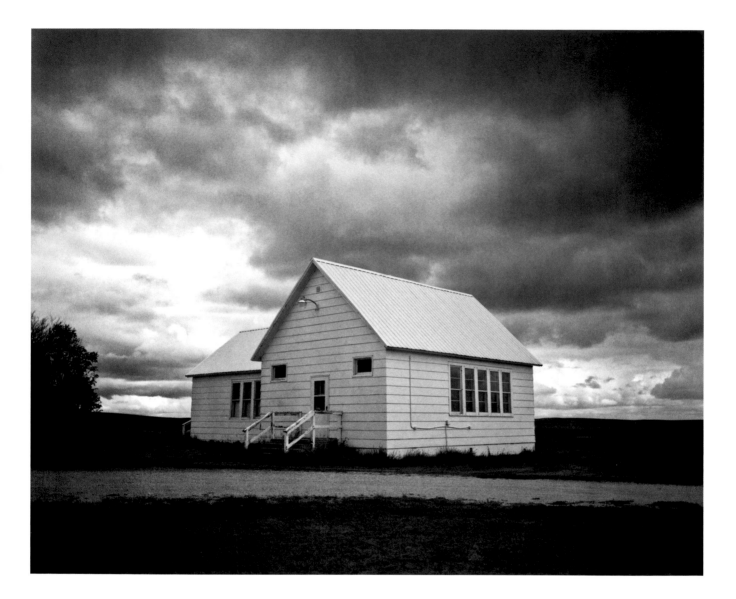

Abandoned Prairie Library, Amidon,
North Dakota, 2012

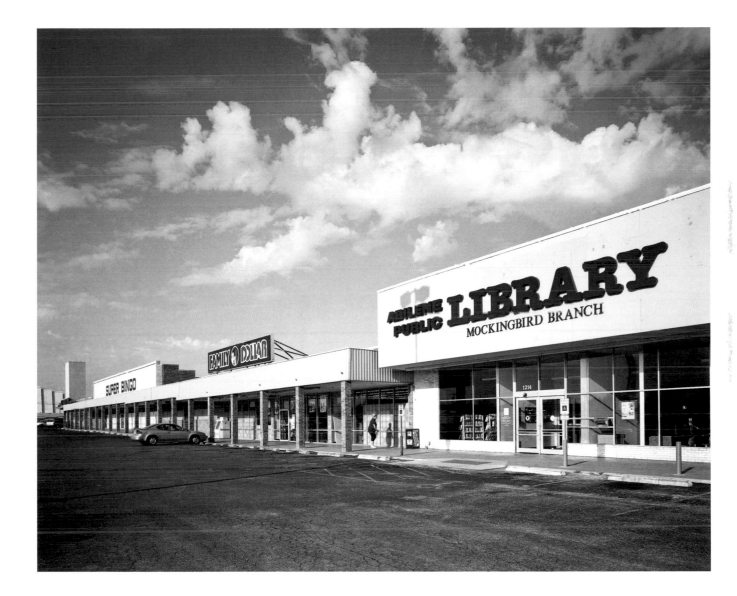

**Super Bingo, Family Dollar, and Mockingbird
Branch Library, Abilene, Texas, 2011**

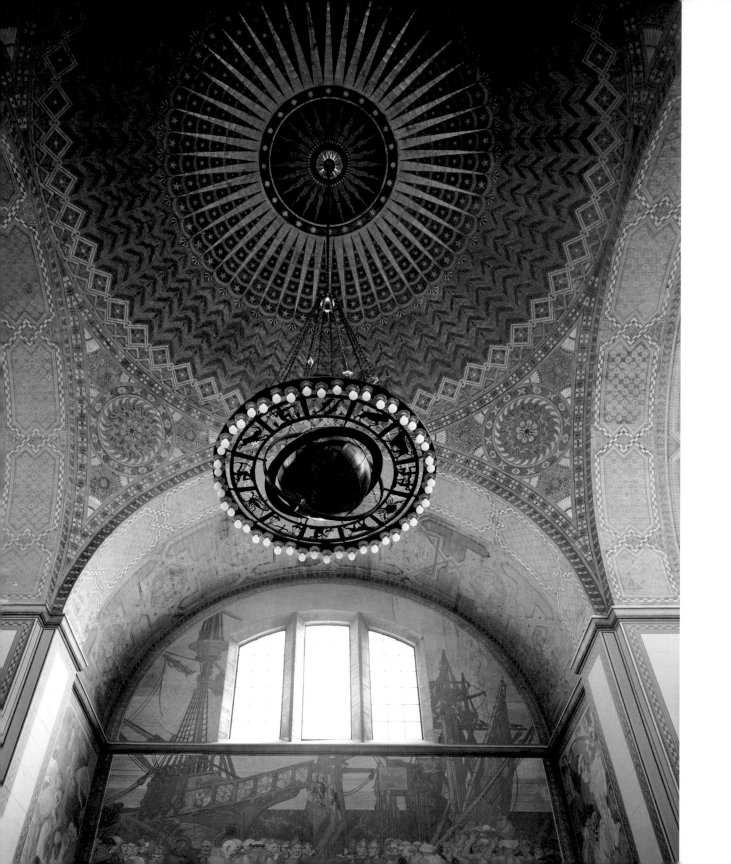

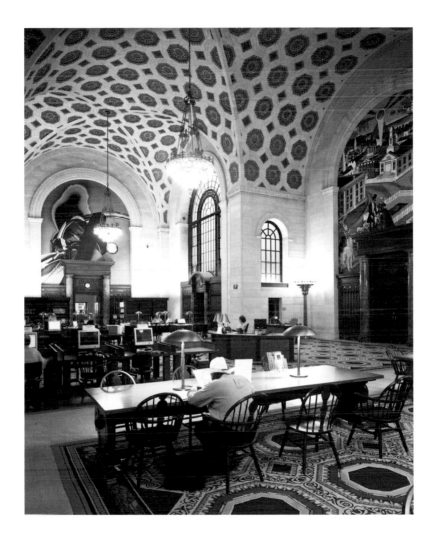

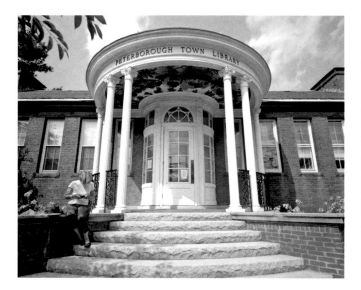

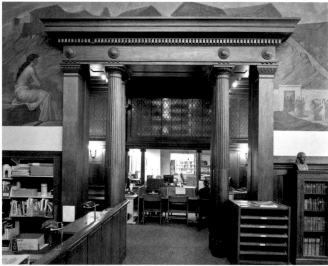

right

Interior, Franklin Public Library, Franklin, Massachusetts, 2011 | The Franklin Public Library claims to be the first lending library in the United States. In 1778 the town was named Franklin in honor of Dr. Benjamin Franklin. When asked to donate a bell for the town's church steeple, Franklin responded with an offer of books for the residents, acknowledging that "sense" was preferable to "sound." In 1790 the citizens voted to lend the books to all Franklin inhabitants free of charge. The vote established the Franklin collection as one of the first public libraries in the United States. The original collection is still housed in a bookcase in the library's reading gallery.

left

First tax-supported public library, Peterborough Town Library, Peterborough, New Hampshire, 2009 | Many American public libraries have claimed to be the oldest. However, Peterborough Town Library is the first tax-supported library in the United States. In 1833 it established the principle of a free public library supported by the community through taxation—an idea that later spread throughout the world.

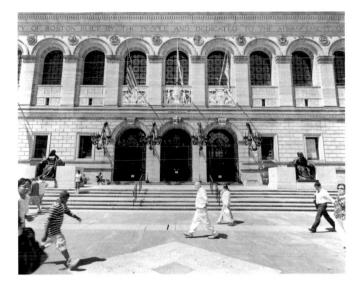

left

Central Library, Boston, Massachusetts, 2008 | Founded in 1848, the Boston Public Library holds a number of "first" distinctions. In addition to being the first publicly supported, free big-city library in the world, it was the first to lend books and the first to establish space designated specifically for children. The Boston Public Library is the third-largest library system in the country. It also serves as a presidential library, housing the papers of John Adams.

right

Darby Free Library, Darby, Pennsylvania, 2011 | The Darby Free Library claims to be "America's oldest public library, in continuous service since 1743." The library was recently threatened with closure.

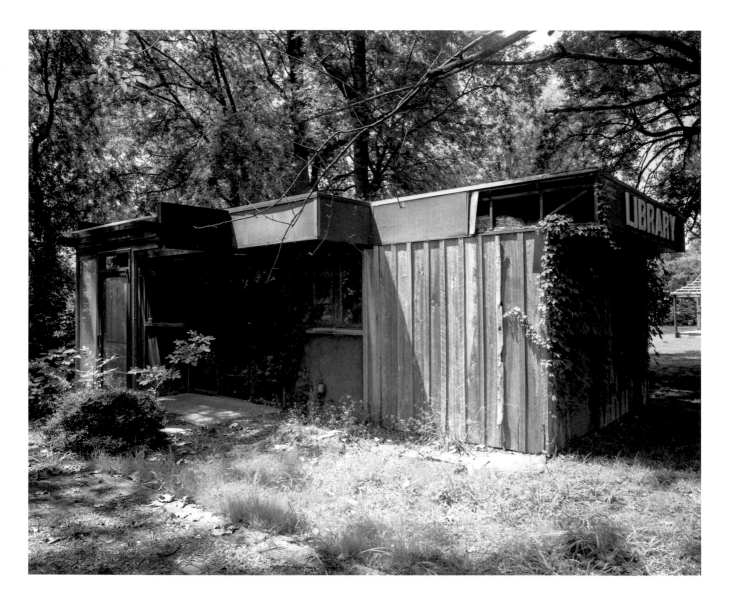

Abandoned library, Sunflower, Mississippi, 2011

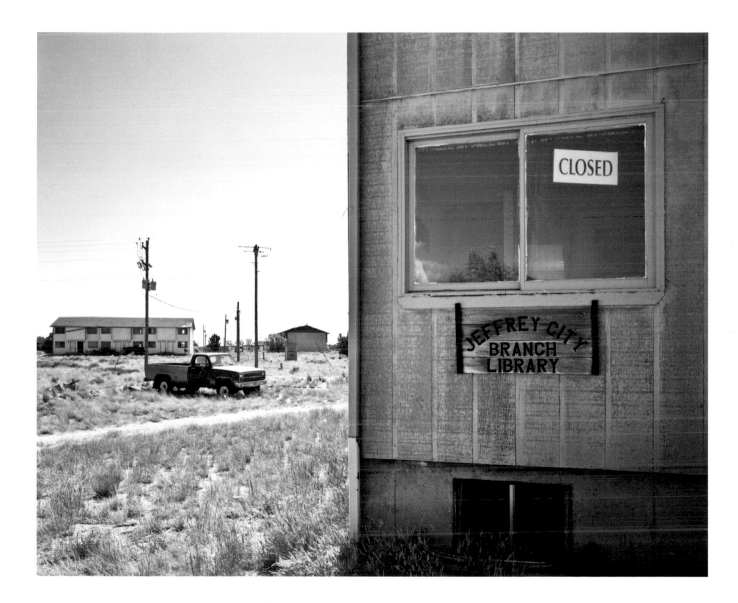

Abandoned library in the deserted town of Jeffrey City, Wyoming, 2012 | Jeffrey City is a former uranium-mining boomtown located in the central part of Wyoming—a boomtown that went bust, as the mine was shut down in 1982 and more than 95 percent of the inhabitants left within three years. The population was fifty-eight in 2010.

Former nightclub and library, East St. Louis, Illinois, 2012 | Eight hundred years ago this area was the site of the Cahokian civilization, which gave rise to the only city north of the Rio Grande River at that time. Situated between the famous Gateway Arch of St. Louis and the Cahokia Mounds State Historic Site, East St. Louis can see alternate possible futures in both. This troubled city embodies the ambition and determination of the westward pioneers and also the potential collapse of an entire region. Originally built as an Elks Club, this abandoned library was once a popular nightclub, where local jazz musician Miles Davis got his start.

THE LIBRARY SPIRIT

Stuart A. P. Murray

First came the readers. They were explorers, traders, farmers, soldiers, servants, gentry, and pilgrims. Some sought a water passage to India or China, others to make a fortune or a new start, and many to worship in freedom. Later came the books.

The early American colonists set out from a Europe that was rich with books, but they brought few with them, as their vessels had little room, crammed with people, livestock, tools, munitions, rations, and seed. In the New World of the 1600s, the books left at home were sorely missed. Those that were brought across the water were treasured, kept in a place of honor—on a chest of drawers shipped over from the old country; on a rough-hewn shelf near the hearth in a frontier cabin; on top of a sideboard made by a colonial cabinetmaker who also might be a blacksmith, a fruit grower, and a fur trader.

Most household collections hardly amounted to a library: the family Bible, a book of hymns; there might be the memoirs of seafarers and voyagers who had gone before, a few of Shakespeare's plays, perhaps John Milton's *Paradise Lost* and, later, John Locke's writings on natural law and the social contract.

The American colonies grew and prospered through the 1600s, and books began to arrive by the crateful at the docks of New York, Philadelphia, Charleston, and Boston. Usually, they were inspected promptly for their suitability and morality according to the lights of the dominant culture of the colony: Puritan, Anglican, Presbyterian, or Catholic; Parliamentarian or Royalist, Whig or Tory. If considered blasphemous, heretical, or politically provocative, a book never left the dock, but was burned on the spot by the local minister, priest, or governor's representative. Still, more books kept coming, until there were too many to be inspected or burned, or perhaps were too important to the influential colonials who had ordered them and whose private libraries were growing.

Also growing was a certain "library spirit," and private book collections were eventually bequeathed to become public libraries. In New York City, the foundation of the New York Society Library was laid in 1700, when Reverend John Sharp, chaplain to the British Army, left his library to the city. One historian said Reverend Sharp manifested a kindly care for those who should come after him, and, at his death, left those books which had been

his solace and his strength, for the use of the public, to whisper words of wisdom and of warning to those who might turn for a moment from the pursuits of trade to listen to their teachings. [7]

The pursuit of trade was a passion in this vast and bountiful country. Colonials pushed ever deeper inland to trade or make war with the native peoples, to settle and survive and flourish. They also had a passion for books and the knowledge found in them, consuming the latest titles on religion, history, politics, economics, and theology, as well as novels and volumes of poetry. This reading was sometimes augmented by manuals on artillery and how to organize and train militias.

In 1731 the library spirit of colonial America inspired Benjamin Franklin and fifty kindred souls to establish the Library Company of Philadelphia. Franklin called it the "mother" of all the American subscription libraries that were to follow. Subscribing members pooled their books and paid a fee to borrow from the collection, raising funds to purchase more books. The Library Company assembled maps, fossils, antique coins, minerals, and scientific instruments such as telescopes and microscopes—all to be loaned out in the shared quest for knowledge. The company even began printing its own titles.

This American library spirit stimulated education and investigation that converged with a developing self-reliance and a sense of independence. The colonists studied philosophy and politics, and they debated the meaning of inalienable rights and liberty. A royal governor of Virginia railed against "free schools and printing," claiming them to be the root of "learning," which, he said, promoted "disobedience, and heresy." [8]

Indeed, the quest for knowledge and autonomy in the colonies led inexorably to the struggle for political freedom that culminated in the American Revolution. After independence and union in the 1780s, Americans journeyed westward, their books finding places in wagons and flatboats—books cherished by emigrants on daunting journeys whose end the travelers did not know.

In the 1800s the nation's appetite for book-learning led to libraries appearing along with new communities and schools, to meet the demand for education and guided by a newborn missionary zeal for uplifting the people through the power of the book. Governments recognized that education was essential to progress. In 1816 Indiana authorized the establishment of county library systems. In 1833 Peterborough, New Hampshire, founded the first wholly tax-supported local public library in the United States, the model for the modern community library—open to all and free of charge. Two years later, New York State took the innovative step of authorizing school districts to raise taxes for supporting libraries that were to be managed by local schools and open to the people. By 1850 libraries in New York State's public schools contained more than 1.5 million books.

American libraries thrived, and the "library movement" was fully under way when an Ohio librarian wrote that its "vitalizing force" and "guiding spirit" was the widely held conviction that "knowledge should be free." [9] Yet, for lovers of books, the library spirit went beyond acquiring knowledge, as is evident in "The Boston Athenaeum," written early in the 1900s by Amy Lowell, who describes her time spent in this library, which her grandfather helped found:

Thou dear and well-loved haunt of happy hours,
How often in some distant gallery,
Gained by a little painful spiral stair,
Far from the halls and corridors where throng
The crowd of casual readers, have I passed
Long, peaceful hours seated on the floor
Of some retired nook, all lined with books,
Where reverie and quiet reign supreme!…
And as we sit long hours quietly,
Reading at times, and at times simply dreaming,
The very room itself becomes a friend,
The confidant of intimate hopes and fears;…
For books are more than books, they are the life,
The very heart and core of ages past.…

The library movement, which also swept Europe, was irrepressible, a vital force for good. As for the concept of library spirit, it took on a more concrete aspect late in the 1800s, when New York State librarian Melvil Dewey established the first school for professional librarians. Dewey described the library spirit as rising from the combination of professional librarianship and state support for libraries: public libraries and librarians would become indispensable to those members of the general public who sought to further their education.

The hundreds of librarians (mainly single women) who graduated from Dewey's program and others like it enthusiastically spread the gospel of books and reading to an audience looking for richer and deeper lives. They personified the library spirit, and many played key roles in the robust post–Civil War women's movement.

In this era, the individual most influential to the library movement was industrialist Andrew Carnegie, who, from 1881 until his death in 1919, gave away $333 million, much of it for the building of public libraries—more than fourteen hundred in the United States alone. As a boy, Carnegie had spent his own happy hours in a private library in Allegheny, Pennsylvania. The owner of that library had opened it to the working children of the town, and in his youth, Carnegie resolved that "if ever wealth came" to him, he would help other young people have access to libraries. [10] With each grant Carnegie made for a new public library, he stipulated that the community must agree to support it. He also required library trustees to maintain an unusual and progressive policy: the stacks must be open to the public. At the start of the twenty-first century, more than thirteen hundred of Carnegie's library buildings were still in use as libraries.

In the United States, public libraries and their branches now number almost seventeen thousand, and there are almost eighty-two thousand public school libraries. [11] Although Americans' reading time fell by 50 percent between 1925 and 1995, by the first decade of the new century, audiovisual circulation grew to 25 percent of total library circulation. Circulation from public libraries rose from 425 million in 1939 to 1.3 billion in 1990 and 2.46 billion in 2010. As ever, young people are a major portion of the population using public libraries, and juvenile borrowers account for 35 percent of total circulation. [12]

The library spirit that enthralled Amy Lowell still has meaning for those who find their own quiet nooks among the stacks on a springtime afternoon, when, as she wrote, "the shifting sun . . . splashes on the floor and on the books / Through old, high, rounded windows, dim with age."

Lowell notes some "old and worn" books and contemplates how they first appeared in the days of her forebears:

> Our fathers' fathers, slowly and carefully
> Gathered them, one by one, when they were new....
> And here we feel that we are not alone,
> We too are one with our own richest past....

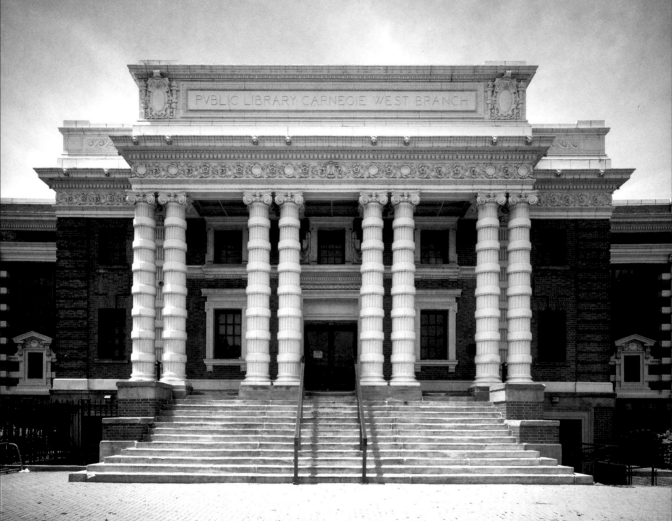

PVBLIC LIBRARY CARNEGIE WEST BRANCH

Carnegie West Branch Library,
Cleveland, Ohio, 2011

ECONOMICS

———

What do libraries say about who we are as a nation? One measure is through the wide spectrum of poverty and wealth on display at local public libraries. After a natural disaster, libraries sometimes act as a place of shelter or healing. For communities experiencing economic or man-made disasters, libraries can do much to help as well.

Philanthropy has always played an important role in the growth of public libraries. Perhaps the greatest gift that steel magnate Andrew Carnegie gave to America in the early twentieth century was to double the number of public libraries in the United States. Some would argue that this type of giving is a self-centered act designed to create monuments to the patron. Others merely wish that wealthy people such as Carnegie had been even more generous. Philanthropic giving continues to play an important role in today's public libraries.

A COUNTRY WITHOUT LIBRARIES

Charles Simic

Outside of a dog, a book is a man's best friend. Inside of a dog, it's too dark to read.
—GROUCHO MARX

All across the United States, large and small cities are closing public libraries or curtailing their hours of operations. Detroit, I read a few days ago, may close all of its branches and Denver half of its own: decisions that will undoubtedly put hundreds of its employees out of work. When you count the families all over this country who don't have computers or can't afford Internet connections and rely on the ones in libraries to look for jobs, the consequences will be even more dire. People everywhere are unhappy about these closings, and so are mayors making the hard decisions. But with roads and streets left in disrepair; teachers, policemen, and firemen being laid off; and politicians in both parties pledging never to raise taxes, no matter what happens to our quality of life, the outlook is bleak. "The greatest nation on earth," as we still call ourselves, no longer has the political will to arrest its visible and precipitous decline and save the institutions on which the workings of our democracy depend.

I don't know of anything more disheartening than the sight of a shut-down library. No matter how modest its building or its holdings, in many parts of this country a municipal library is often the only place where books in large number on every imaginable subject can be found, where both grownups and children are welcome to sit and read in peace, free of whatever distractions and aggravations await them outside. Like many other Americans of my generation, I owe much of my knowledge to thousands of books I withdrew from public libraries over a lifetime. I remember the sense of awe I felt as a teenager when I realized I could roam among the shelves, take down any book I wanted, examine it at my leisure at one of the library tables, and if it struck my fancy, bring it home. Not just some thriller or serious novel, but also big art books and recordings of everything from jazz to operas and symphonies.

In Oak Park, Illinois, when I was in high school, I went to the library two or three times a week, though in my classes I was a middling student. Even in wintertime, I'd walk the dozen blocks to the library, often in rain or snow, carrying a load of books and records to return, trembling with excitement and anticipation at all the tantalizing books that awaited me there. The kindness of the librarians, who, of course, all knew me well, was also an inducement. They were happy to see me read so many books, though I'm

sure they must have wondered in private about my vast and mystifying range of interests.

I'd check out at the same time, for instance, a learned book about North American insects and bugs, a Louis-Ferdinand Céline novel, the poems of Hart Crane, an anthology of American short stories, a book about astronomy, and recordings by Bix Beiderbecke and Sidney Bechet. I still can't get over the generosity of the taxpayers of Oak Park. It's not that I started out life being interested in everything; it was spending time in my local, extraordinarily well-stacked public library that made me so.

This was just the start. Over the years I thoroughly explored many libraries, big and small, discovering numerous writers and individual books I never knew existed, a number of them completely unknown, forgotten, and still very much worth reading. No class I attended at the university could ever match that. Even libraries in overseas army bases and in small, impoverished factory towns in New England had their treasures, like long-out-of-print works of avant-garde literature and hard boiled detective stories of near-genius.

Wherever I found a library, I immediately felt at home. Empty or full, it pleased me just as much. A boy and a girl doing their homework and flirting; an old woman in obvious need of a pair of glasses squinting at a dog-eared issue of the *New Yorker*; a prematurely gray-haired man writing furiously on a yellow pad surrounded by pages of notes and several open books with some kind of graphs in them; and, the oddest among the lot, a balding elderly man in an elegant blue pinstripe suit with a carefully tied red bow tie, holding up and perusing a slim, antique-looking volume with black covers that could have been poetry, a religious tract, or something having to do with the occult. It's the certainty that such mysteries lie in wait beyond its doors that still draws me to every library I come across.

I heard some politician say recently that closing libraries is no big deal, since the kids now have the Internet to do their reading and schoolwork. It's not the same thing. As any teacher who recalls the time when students still went to libraries and read books could tell him, study and reflection come more naturally to someone bent over a book. Seeing others, too, absorbed in their reading, holding up or pressing down on different-looking books, some intimidating in their appearance, others inviting, makes one a participant in one of the oldest and most noble human activities. Yes, reading books is a slow, time-consuming, and often tedious process. In comparison, surfing the Internet is a quick, distracting activity in which one searches for a specific subject, finds it, and then reads about it —often by skipping a great deal of material and absorbing only pertinent fragments. Books require patience, sustained attention to what is on the page, and frequent rest periods for reverie, so that the meaning of what we are reading settles in and makes its full impact.

How many book lovers among the young has the Internet produced? Far fewer, I suspect, than the millions libraries have turned out over the last hundred years. Their slow disappearance is a tragedy, not just for those impoverished towns and cities, but for everyone everywhere terrified at the thought of a country without libraries.

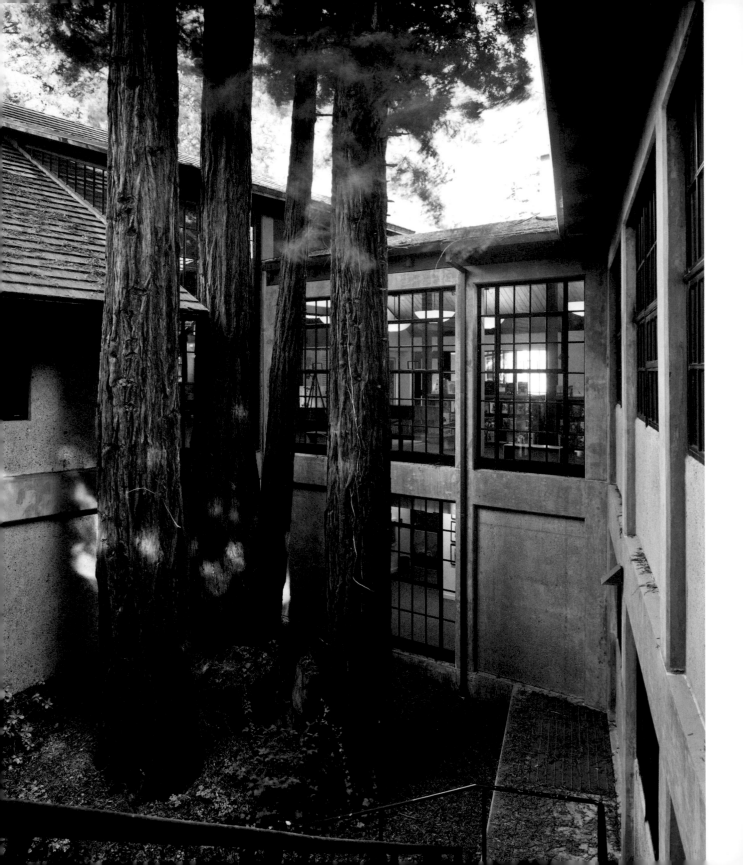

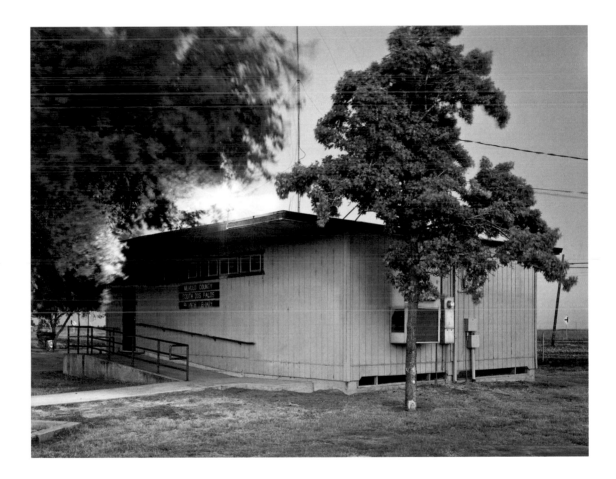

opposite

Redwoods, Mill Valley Public Library, Mill Valley, California, 2012

above

Merced County Branch Library, South Dos Palos, California, 2010 | This public library is in a poor Hispanic community in California's agriculturally based San Joaquin Valley.

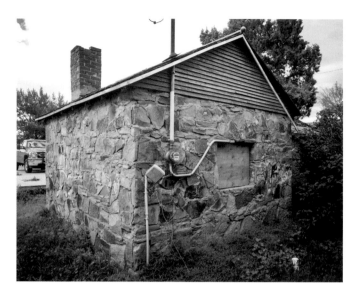

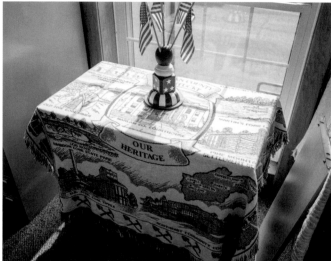

left

Former Dakota Club Library, Eagle Butte, South Dakota, 2012 | The Cheyenne River Indian Reservation is one of the poorest parts of the United States. Eagle Butte, South Dakota, is the center of this area, and its population is almost all Native American. It once hosted the incredible Dakota Club Library. In the 1930s Eagle Butte was an all-white town. A group of civic-minded women started the library in an old pioneer sod house that was later covered in rock. The day we were there, the old library was sadly covered with graffiti and was closed. The new one was in a windowless metal building that contained two computers, only one of which worked. This was the only Internet connection for a town of 3,300 people whose annual per capita income was $5,000 a year. With a 70 percent unemployment rate, it was simply too expensive for people here to pay $40 a month for Internet service, let alone to buy a computer.

right

"Our Heritage" wall hanging in Harlan County Public Library, Harlan, Kentucky, 2011 | Violent confrontations occurred here between coal miners and mine owners in the 1930s and in the 1970s.

Library in heat wave, no air conditioning, no computers, lights out to keep cooler, Tchula Public Library, Tchula, Mississippi, 2011 | Tchula, Mississippi, is located in the poorest county of the poorest state in the country. Holmes County has the lowest life expectancy in the United States. On the incredibly hot day we photographed here, the library was open but the air conditioning was broken. The very patient librarian, drenched in sweat, had shut off the lights to keep the sweltering library a little cooler. A sign on the door stated "Public access computers will NOT be available to the Public due to excessive heat conditions in the Library because there is NO AIR CONDITIONING. Computer services will resume once the air conditioning is restored!!! Thank you." The air conditioner had been broken for a year.

Closed main library, Camden Free Public Library, Camden, New Jersey, 2011 | Most of this once-extensive library system was threatened with closure in 2010. This main library closed in 2011. As a result, residents needed to search elsewhere for access to books and computers in one of the poorest and most dangerous cities in the country.

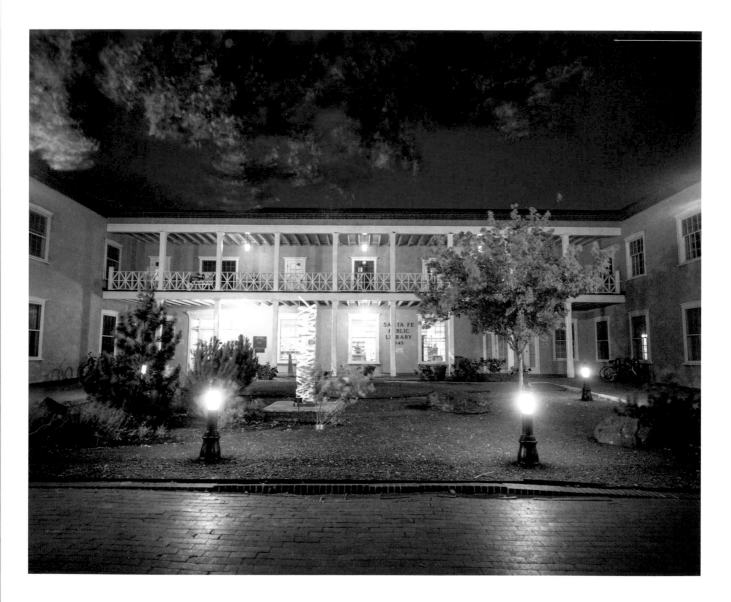

Exterior at night, Main Library, Santa Fe,
New Mexico, 2011

Storrs Library, Longmeadow,
Massachusetts, 2011

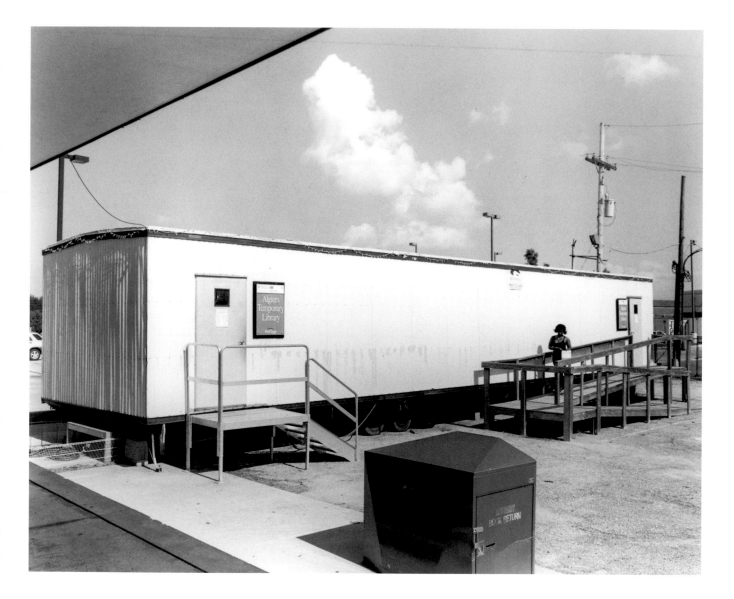

Three years after Hurricane Katrina, Algiers
temporary library, New Orleans, Louisiana, 2008

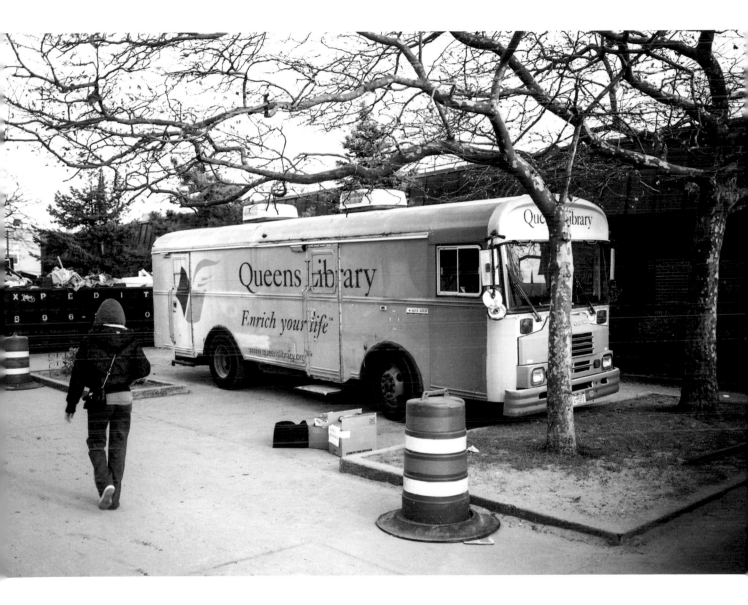

After Hurricane Sandy, Queens Library bookmobile,
the Rockaways, Queens, New York, 2012

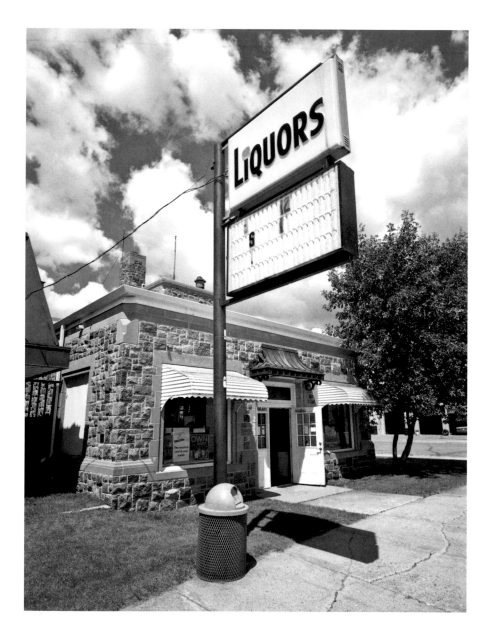

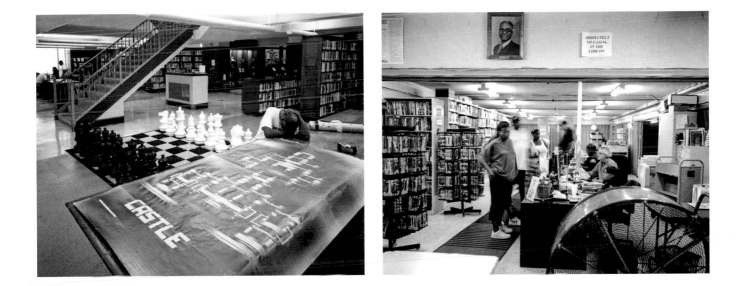

opposite

Liquor store sign and Mahnomen Library, Mahnomen, Minnesota, 2012 | Mahnomen is located in the White Earth Indian Reservation, in one of the poorest counties in Minnesota. It has a fascinating rock-walled library built by the WPA in the 1930s. A giant liquor sign near the front of the library was especially troubling, given the problem of alcoholism in some Indian communities.

left

Chess room, Enoch Pratt Free Library, Baltimore, Maryland, 2011

right

Mark Twain Annex, in the basement of a church, Detroit, Michigan, 2011 | The Mark Twain Branch Library temporarily moved into the basement of the Mt. Calvary Missionary Baptist church in 1996. On the day we were there, the crowded library was stifling. The air conditioner had been broken for the last few weeks during a record heat wave. Large fans moved the air around the library but provided little relief. The Annex was closed in 2011 due to budget cuts.

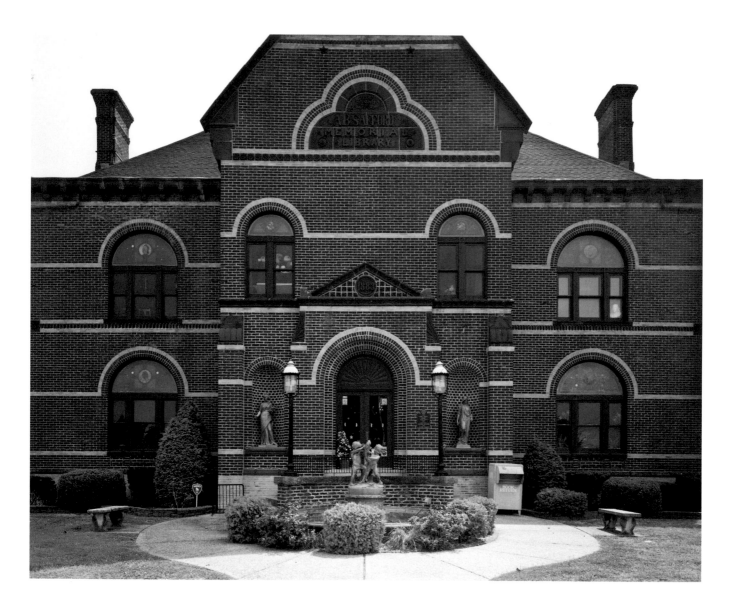

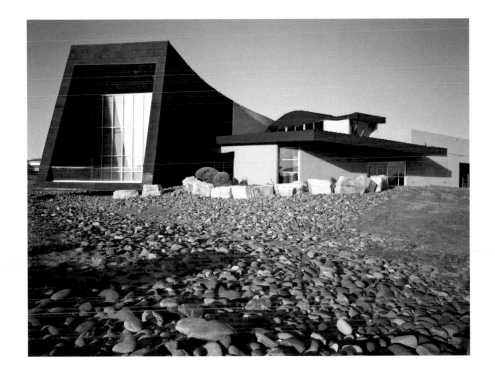

opposite

**A. B. Safford Memorial Library, Cairo, Illinois,
2012** | Cairo is located on the southern tip of
Illinois, on the northern edge of the Mississippi Delta.
It had fallen on hard times following an astonishing
history of racial violence during the twentieth
century, including several lynchings and race riots.
Its history of violence, along with high unemploy-
ment, eventually depopulated much of the town.
Today it seems like a collapsed city. Like many of
the shattered towns we have visited (East St. Louis,
Detroit, Camden), it has an incredible library that
was built during better times. It is difficult to
understand how towns that are now suffering so
much had once been able to produce such opulent
libraries and civic infrastructure. Cairo's racial
violence was famous, but so is its library, a symbol
of hope and transformation.

above

**Esperanza Moreno Regional Branch Library,
El Paso, Texas, 2011** | El Paso lies on the Rio Grande
just north of Ciudad Juárez, Mexico. Together the
two cities comprise the second-largest binational
metropolitan area on the United States–Mexican
border. Ciudad Juárez is one of the fastest-growing
cities in the world and "the most violent zone in
the world outside of declared war zones." [13] At the
Moreno branch library, in a suburb of El Paso,
we encountered wealthy Mexicans who had moved
to escape the violence of Juárez. The suburb's
population was changing from Chicano to Mexican. [14]

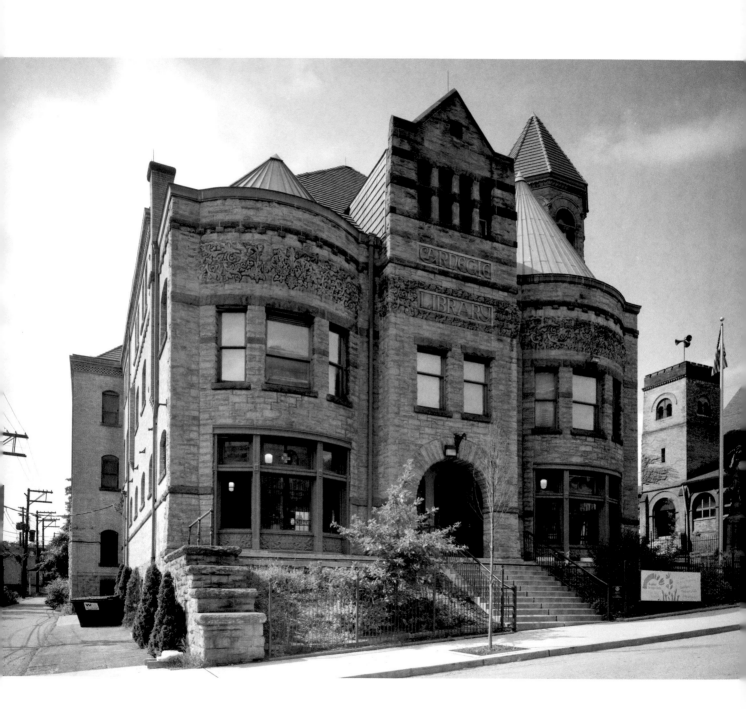

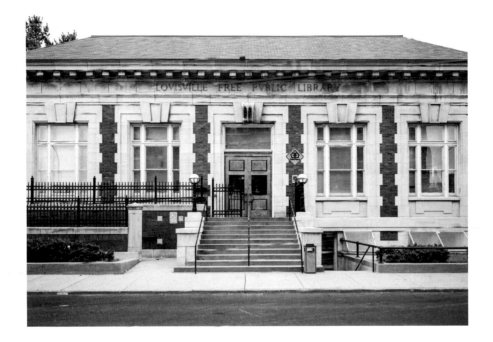

opposite

First Carnegie library: the Braddock Carnegie Library, Braddock, Pennsylvania, 2011 | I used my large-format view camera to photograph this original Carnegie library in the old, gritty steel town of Braddock, Pennsylvania. The once glorious but now faded interior included a gym, a theater, and a swimming pool, as well as book collections and reading rooms. Outside, while I was focusing the camera under the dark cloth, a hand reached in and tried to grab the tripod. I instinctively pushed it away and as I came out from the dark cloth a crazed man socked me in the jaw. Fortunately, Walker was right behind me, and as we screamed at the man, he slunk away, muttering darkly.

above

Formerly segregated Carnegie library: the Western Library, Louisville, Kentucky, 2011 | This is the first Carnegie public library built for African Americans in the United States during the period of segregation in the American South.

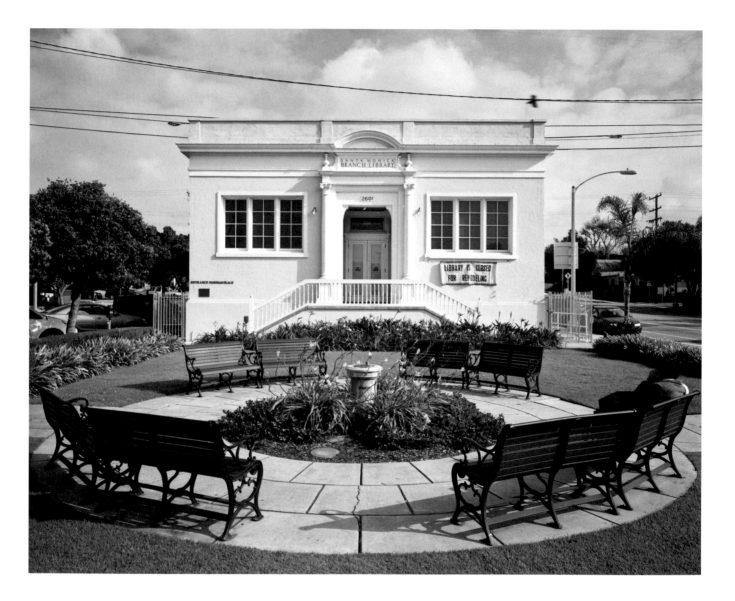

Carnegie library, Ocean Park Branch Library,
Santa Monica, California, 2011

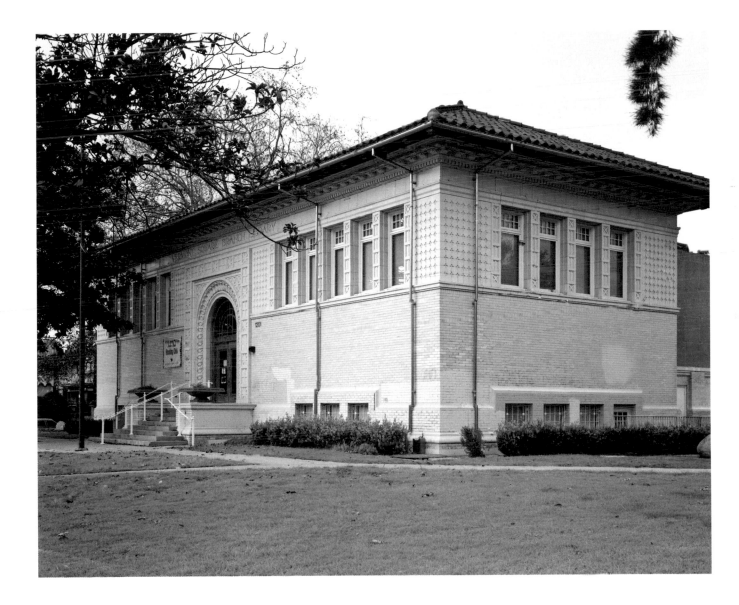

Vermont Square Branch Library, Los Angeles, California, 2011 | This was the first library built in Los Angeles, in 1913. Formally called South Central, this area was home to one of the first jazz scenes in the western United States and later became associated with urban decay and street crime.

above
**Carnegie library: Seward Park Branch Library,
New York, New York, 2011**

opposite
**Gargoyle, Woburn Public Library, Woburn,
Massachusetts, 1994**

54 THE PUBLIC LIBRARY

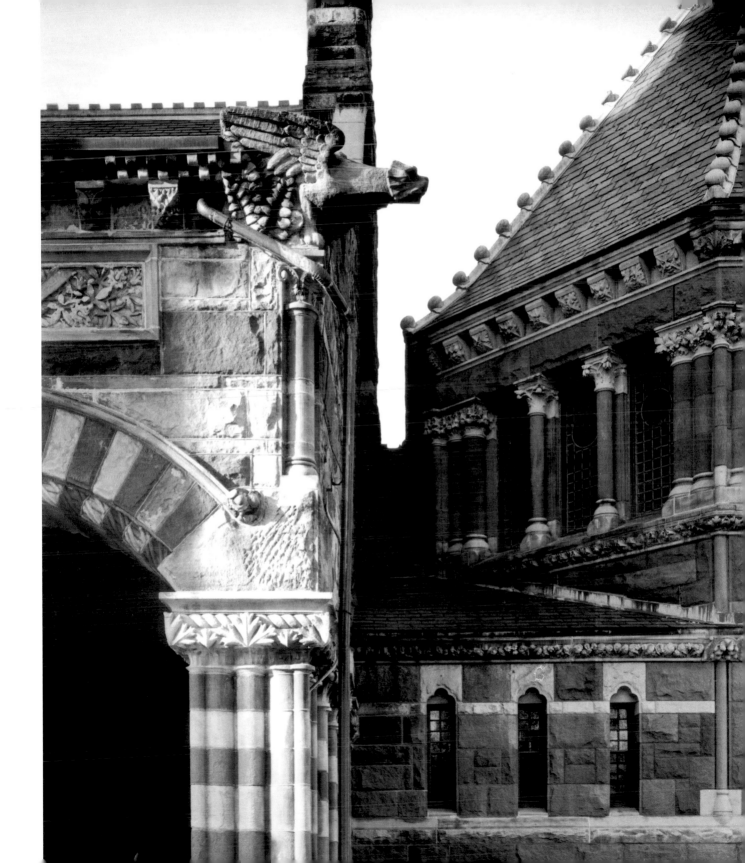

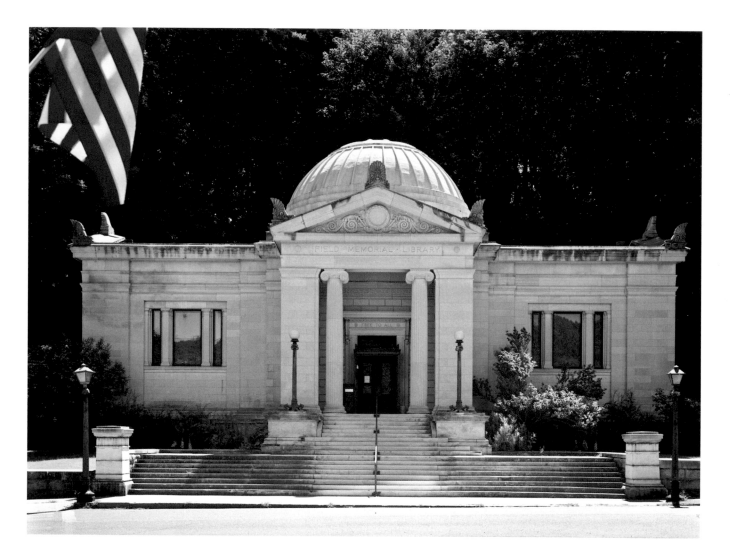

Field Memorial Library, Conway,
Massachusetts, 2011

ALL HAIL THE PUBLIC LIBRARY

David Morris

The word "PUBLIC" has been removed from the name of the Fort Worth Library. Why? Simply put, to keep up with the times.

—"Fort Worth Library Unveils New Identity," media release issued by the city of Fort Worth, June 11, 2008

In an age of greed and selfishness, the public library stands as an enduring monument to the values of cooperation and sharing. In an age where global corporations stride the earth, the public library remains firmly rooted in the local community. In an age of widespread cynicism and distrust of government, the 100 percent tax-supported public library has virtually unanimous and enthusiastic support. This is not the time to take the word *public* out of the public library. It is time to put it in capitals.

The public library is a singularly American invention. Europeans had subscription libraries for one hundred years before the United States was born. But on a chilly day in April 1833, the good citizens of Peterborough, New Hampshire, created a radical new concept—a truly public library. All town residents, regardless of income, had the right to freely share the community's stored knowledge. Their only obligation was to return the information on time and in good condition, allowing others to exercise that same right.

By the 1870s eleven states boasted 188 public libraries all combined. By 1910 all states had them. Today almost nine thousand central buildings, plus about seventy-five hundred branches, have made public libraries one of the most ubiquitous of all American institutions. More than half of us carry library cards, and a 2011 Harris poll showed that about 65 percent of us had visited a public library at least once in the past year. [15]

Since its inception, the American public library's prime directive has been to protect the public's access to information. In 1894 the right to know led Denver's public library to pioneer the concept of open stacks. For the first time, patrons had the freedom to browse. In the 1930s the right to know led Kentucky's librarians to ride pack horses and mules with saddlebags filled with books into remote areas of the state.

In 1872 the right to know led the Worcester, Massachusetts, public library to open its doors on Sunday. Many viewed that as sacrilege. Head librarian Samuel Green calmly responded that a library intended to serve the public could do so only if it were accessible when the public could use it. Six-day, sixty-hour work weeks meant that if libraries were to serve the majority of the community, they must be open on Sundays. More than 125 years later, Sundays remain the busiest day of the week for public libraries, and Sunday closings are a library's first sign of fiscal distress.

By 1935 public libraries were serving 60 percent of the population. They had so proven their value that not a single library closed its doors during the Great Depression. To keep its doors open, the Cleveland Public Library sponsored "overdue weeks," encouraging patrons who could afford it to keep their library books until they were overdue, allowing the library to collect the twelve cents per week fine. In a time of soup lines and economic destitution, the library was known as the "bread line of the spirit." [16]

Its mission of protecting our access to information has often led the public library to confront authorities who would obstruct that access. In 1953, at the height of McCarthyism, when magazines like *The Nation* were banned in many places and William Faulkner's novels were seized as pornographic literature, the American Library Association (ALA) adopted a "Freedom to Read" statement. "The freedom to read is of little consequence when the reader cannot obtain matter fit for that reader's purpose," it insisted, "Ideas can be dangerous.... Freedom itself is a dangerous way of life, but it is ours." [17]

In the 1980s and 1990s, when the federal government began giving taxpayer-financed data to private companies, who then copyrighted the information and charged fees for access, the library community expressed its displeasure.

Just as fiercely as public librarians fight to protect our access to information, they fight to protect our personal information from prying eyes. In the 1980s, when the FBI tried to turn librarians into spies by asking them to identify those who checked out military or subversive books or who simply fit a terrorist profile, librarians firmly rejected the request.

Despite their enormous popularity and widespread use, public libraries have rarely been well funded. "Libraries are plagued by the image that we are nice, but not essential," one librarian complained to the *Washington Post*. [18] People will defend their libraries, but only when the lights are about to go out.

And the lights are beginning to go out. US mayors report that library budgets are among the first items on the chopping block now. Nineteen states cut funding for public libraries in 2011. More than half of the reductions were greater than 10 percent. [19] Those cuts were compounded by rising operating costs for electricity, maintenance, materials. The result is that even when operating budgets remain constant, something has to give—fewer books or computers or shorter hours.

In what will undoubtedly be a protracted and bruising fight to expand America's public libraries in a time of financial distress, librarians themselves should not be expected to take the lead. The public should.

Because most libraries get 90 percent of their funding from local taxes, grassroots initiative can have a major impact. When activists have managed to put a library-funding measure on the ballot, they usually win. In 2010 some 87 percent of these ballot initiatives were approved across the country. [20] We need a grassroots effort to defend our public libraries, an effort that can and should be part of a growing nationwide and international effort to defend the public sphere itself.

Such efforts have begun. In Bedford, Texas, after a communitywide petition campaign to oppose library outsourcing gathered seventeen hundred signatures in four days, city council members voted 4 to 3 to reject privatization.

In Philadelphia grassroots organizations such as Coalition to Save the Libraries sprang up in 2008, after the city, without a formal vote of the city council, announced it was going to close eleven library branches. Residents of

nine of the affected neighborhoods plus several city council members filed suit, citing a 1988 ordinance that no city-owned facility may close, be abandoned, or go into disuse without city council approval. After two days of hearings packed with library supporters and just hours before the mandated closure, Judge Idee C. Fox granted an injunction against the closures.

In her ruling, Judge Fox made clear the city's decision was about more than money, "The decision to close these eleven library branches is more than a response to a financial crisis; it changes the very foundation of our city." [21]

Fort Worth got it wrong. We need to put the *public* back into public library.

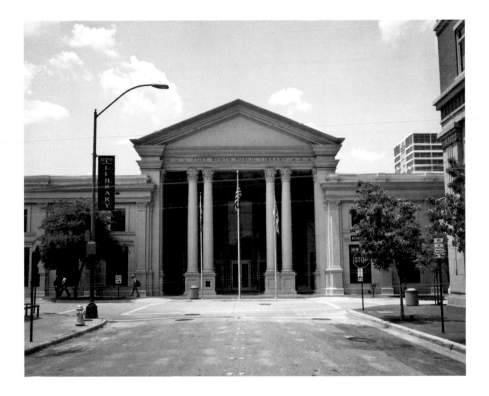

Fort Worth Library, Fort Worth, Texas, 2011

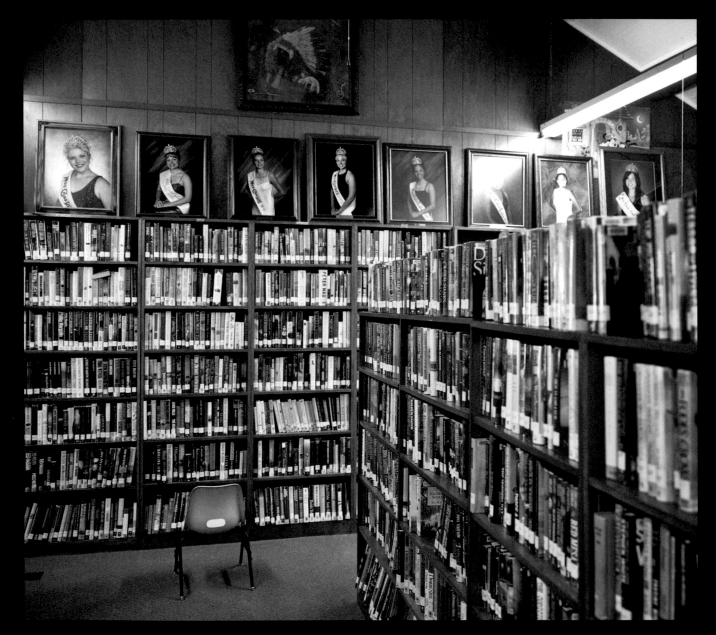

**Miss Cass Lake winners, Cass Lake Community
Library, Cass Lake, Minnesota, 2012**

CIVIC MEMORY
AND IDENTITY

The civic memory of our nation's communities is often housed in their local public libraries. Generations of stories, books, maps, magazines, photographs, memories, and archives can be found in their collections. Without these memories, we would not be able to remember who we are, where we come from, and where we are going. Ethnic and cultural identity can be a part of civic identity. Libraries are a source of local pride where communities form bonds through shared experiences, memories, and hopes.

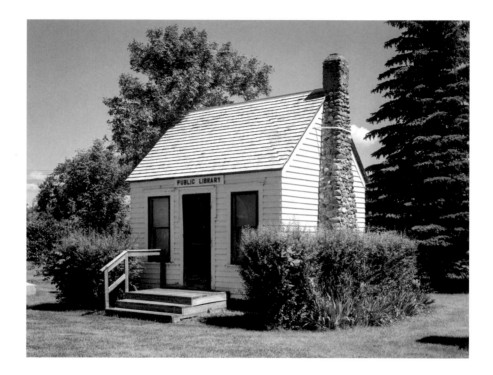

Library, Roscoe, South Dakota, 2012 | This
library was built in 1932 in the small town of Roscoe,
South Dakota, by a group of community-spirited
women called the Priscilla Embroidery Club.
The land for the library was donated, and the women
hauled the rocks for the chimney and foundation
while their husbands constructed the building.
The eight women of the club took turns being
the librarian and maintaining the yard and building.
Books were bought by the clubwomen, but many
books were donated by people in the community.
Approximately fifteen hundred books were in the
library when it closed in 2002. The aging members
of the Priscilla Club were no longer able to maintain
and operate the library. This twelve-by-fourteen-
foot building was known for being one of the smallest
public libraries in the nation.

opposite

**The Handley Regional Library, Winchester,
Virginia, 2011** | A Confederate sympathizer built
this library after the Civil War. Its beautiful
collections include many portraits of Confederate
war heroes.

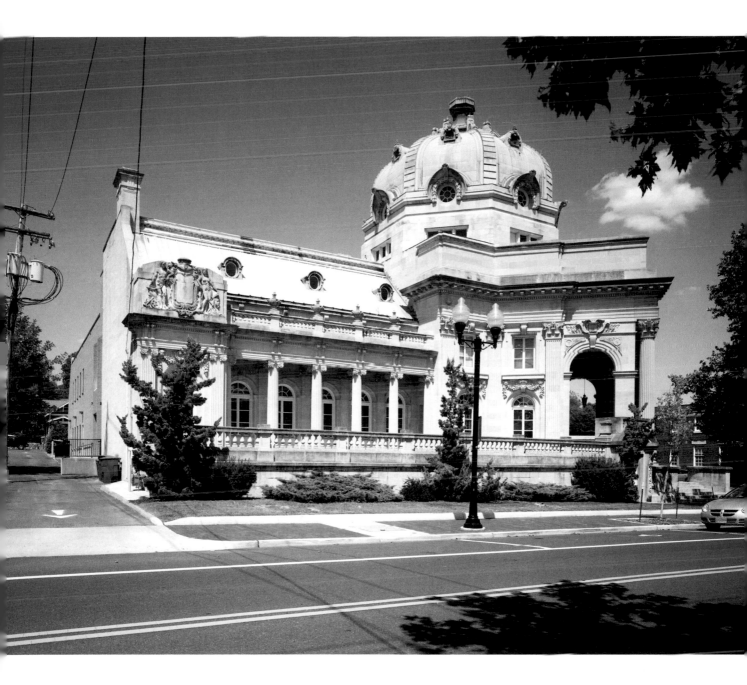

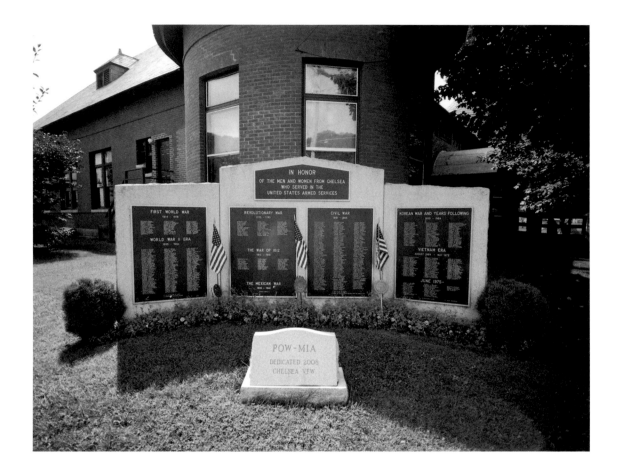

Veterans' memorial and library, Chelsea Public Library, Chelsea, Vermont, 2009 | This memorial commemorates fallen veterans dating back to the Revolutionary War.

Guitar and library, Muskogee Public Library, Muskogee, Oklahoma, 2011 | This town was made famous by the 1969 Merle Haggard song "Okie from Muskogee." Its population is one of the most diverse in the state. Twenty-four different nationalities are represented within the city, and seventeen non-English languages are spoken as first languages. The guitar with the many faces found in this part of Oklahoma perfectly captures the rich, complex heritage of this community.

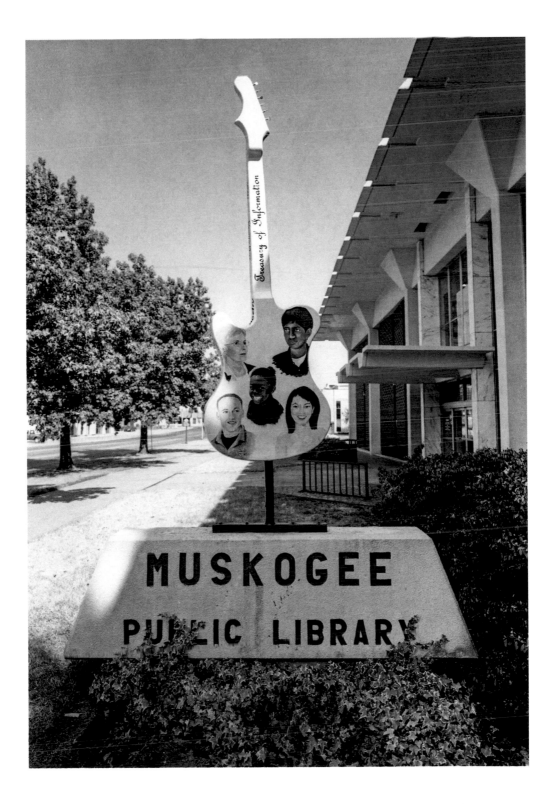

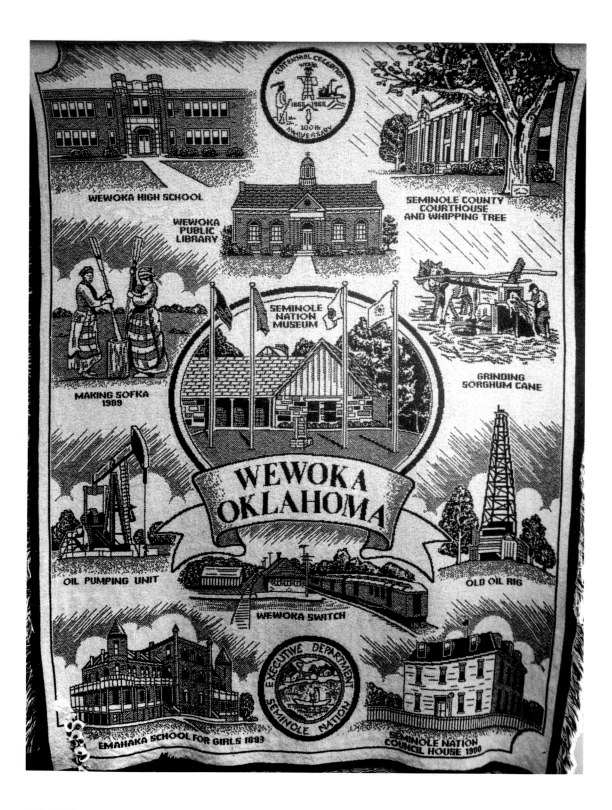

above

Clarksdale High School Band, Carnegie Public Library, Clarksdale, Mississippi, 2011 | We first encountered Phillip Carter playing outstanding blues guitar at Morgan Freeman's Ground Zero Blues Club in Clarksdale, Mississippi. The next morning we met him again as the reference librarian at the Carnegie Public Library. Its upstairs children's room had originally housed the Delta Blues Museum, which started in the library. The Museum now teaches young locals to perform the blues, helping to keep this uniquely American form of music alive.

opposite

Town wall hanging, Wewoka Public Library, Wewoka, Oklahoma, 2011 | Wewoka, Oklahoma, is the capital of the Seminole Indian Nation. The town was founded in 1866 by a group of black Seminoles. Much of Eastern Oklahoma was settled by Indian tribes from the American southeast during the forced migration called the Trail of Tears. Housed in the public library, this tapestry reflects the region's diverse ethnic history.

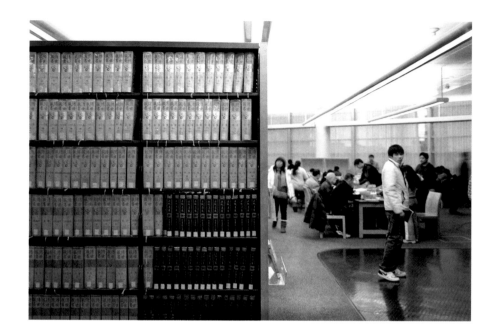

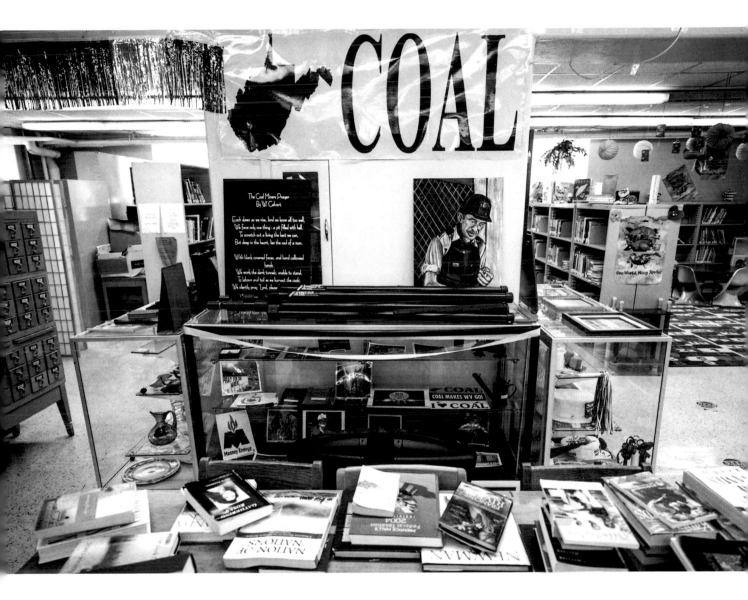

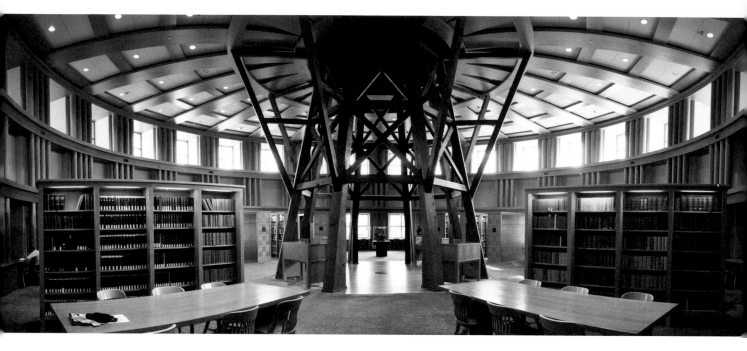

above

Western History Center, Denver Public Library, Denver, Colorado, 2012 | The Denver Public Library's western history and genealogy collections are some of the largest and most celebrated in the West. The building was designed by Michael Graves.

opposite

Fannie Lou Hamer Library, Jackson, Mississippi, 2011 | Fannie Lou Hamer was a famous voting-rights activist and a civil-rights leader. Other prominent Southerners with branch library namesakes in Jackson include civil-rights activist Medgar Evers, writer Eudora Welty, and novelist Richard Wright.

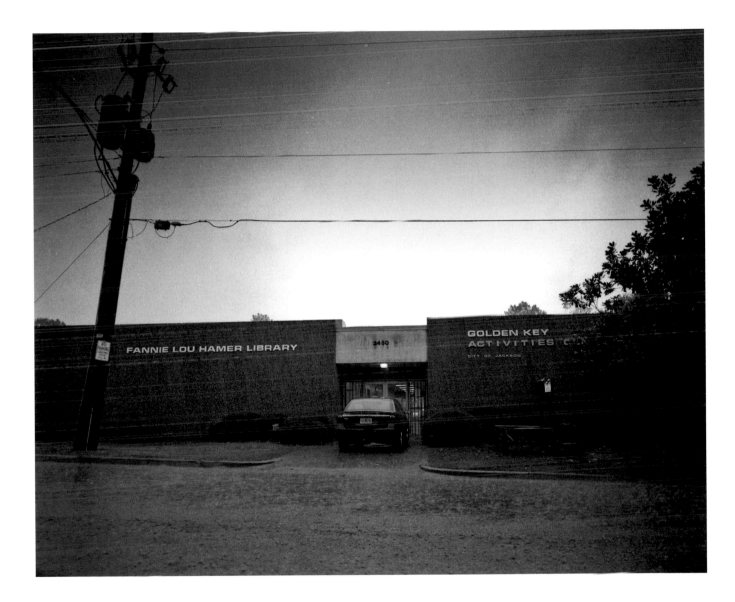

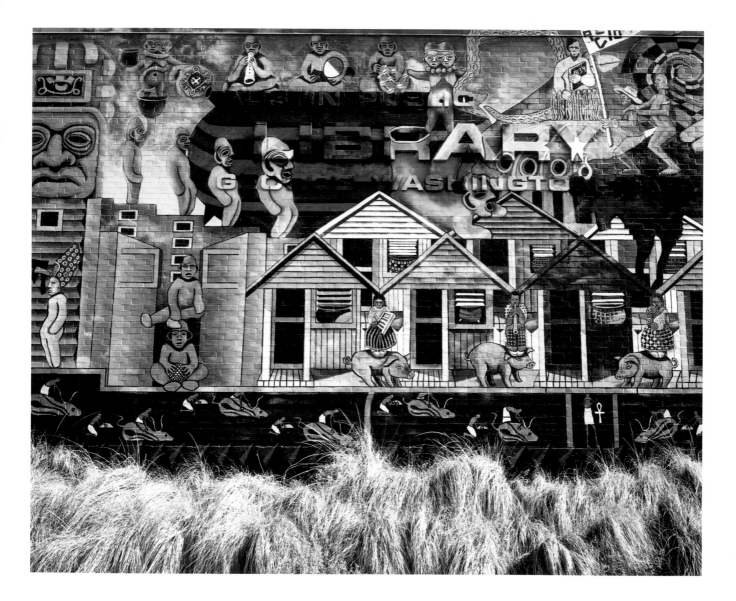

**African American History Library, Oakland,
California, 2011** | This reference library's collection
consists of approximately twelve thousand volumes
by or about African Americans. Its two galleries show
changing exhibitions on art, history, and culture.
This unique public/private partnership is housed in
the former Charles S. Greene Library, an historic
Carnegie building that served as the main library
for Oakland from 1902 until 1951.

opposite

**George Washington Carver Branch Library, Austin,
Texas, 2011** | This mural by John Fisher covers a
wall of the branch library. It depicts the horrors of
the slave trade and celebrates African American
culture. Black citizens in East Austin had strongly
advocated for a library in their community, and this
was the first branch library to serve them.

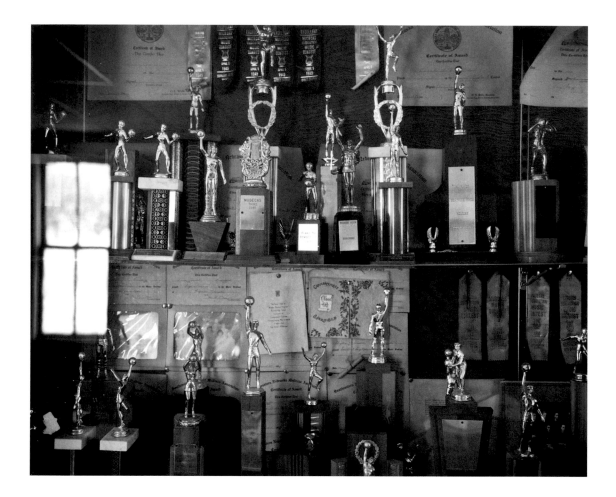

Trophies in library, Burchard, Nebraska, 2012 |
In 2010 there were approximately eighty-two people
living in the small town of Burchard, Nebraska.
The day we were there it seemed abandoned.
Although the library was closed, we noticed that
the door was ajar. Inside, the library's archive
included lists of fallen local soldiers from World
War I and World War II, and high school trophies
and ribbons dating back to the 1930s were in a dusty
display case. The library seemed to contain the
collective civic memory of this Nebraskan village.
The almost empty town is symbolic of the dramatic
depopulation of the Great Plains.

WHAT THE LIBRARY
MEANS TO ME

Amy Tan

*I wrote this essay when I was eight years old, for a contest sponsored by the
Citizens Committee for the Santa Rosa (California) Library. I received a transistor radio
as a prize, and my essay was published in the* Santa Rosa Press Democrat.

My name is Amy Tan, 8 years old, a third grader in Matanzas School. It is
a brand new school and everything is so nice and pretty. I love school
because the many things I learn seem to turn on a light in the little room
in my mind. I can see a lot of things I have never seen before. I can read many interest-
ing books by myself now. I love to read. My father takes me to the library every two
weeks, and I check five or six books each time. These books seem to open many win-
dows in my little room. I can see many wonderful things outside. I always look for-
ward to go the library.

Once my father did not take me to the library for a whole month. He said, the
library was closed because the building is too old. I missed it like a good friend. It
seems a long long time my father took me to the library again just before Christmas.
Now it is on the second floor of some stores. I wish we can have a real nice and pretty
library like my school. I put 18 cents in the box and signed my name to join the
Citizens of Santa Rosa Library.

LETTERS TO THE CHILDREN OF TROY, NEW YORK

Marguerite Hart was the first children's librarian at the Troy Public Library in Troy, New York. In 1971 Hart contacted a number of public figures active in the arts, sciences, and politics, asking each to write a letter to the children of Troy describing the significance of libraries and his or her own experiences of reading.

Hart received ninety-seven letters from a wide range of celebrated correspondents, including First Lady Pat Nixon, Vice President Spiro Agnew, then–Governor of California Ronald Reagan, Governor of New York Nelson Rockefeller, Canadian Prime Minister Pierre Trudeau, Senator Edmund Muskie, civil rights leader Julian Bond, astronaut Neil Armstrong, *Cosmopolitan* editor Helen Gurley Brown, playwright Neil Simon, singer Pearl Bailey, pediatrician and author Dr. Benjamin Spock, and actors Douglas Fairbanks Jr. and Vincent Price. Together, the letter writers represent an engaging cross-section of early 1970s culture; reproduced here are letters from authors Isaac Asimov, Dr. Seuss, and E. B. White.

16 March 1971

Dear Boys and Girls,

Congratulations on the new library,
because it isn't just a library. It is a space
ship that will take you to the farthest
reaches of the Universe, a time machine that will
take you to the far past and the far future,
a teacher that knows more than any human being,
a friend that will amuse you and console you
---and most of all, a gateway, to a better and
happier and more useful life.

Isaac Asimov

Isaac Asimov

Dr. Seuss
7301 Encelio Drive
La Jolla, California 92037

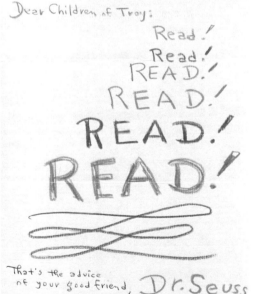

Dear Children of Troy:

Read!
Read!
READ.
READ.
READ!
READ!

That's the advice
of your good friend, Dr. Seuss

E. B. WHITE

NORTH BROOKLIN, MAINE

April 14, 1971

Dear Children of Troy:

Your librarian has asked me to write,
telling you what a library can mean to you.

A library is many things. It's a
place to go, to get in out of the rain. It's a place to
go if you want to sit and think. But particularly it is
a place where books live, and where you can get in touch
with other people, and other thoughts, through books. If
you want to find out about something, the information is
in the reference books---the dictionaries, the encyclopedias,
the atlases. If you like to be told a story, the library is
the place to go. Books hold most of the secrets of the
world, most of the thoughts that men and women have had.
And when you are reading a book, you and the author are
alone together---just the two of you. A library is a good
place to go when you feel unhappy, for there, in a book,
you may find encouragement and comfort. A library is a
good place to go when you feel bewildered or undecided,
for there, in a book, you may have your question answered.
Books are good company, in sad times and happy times, for
books are people---people who have managed to stay alive
by hiding between the covers of a book.

E B White

HOW MR. DEWEY DECIMAL SAVED MY LIFE

Barbara Kingsolver

A librarian named Miss Truman Richey snatched me from the jaws of ruin, and it's too late now to thank her. I'm not the first person to notice that we rarely get around to thanking those who've helped us most. Salvation is such a heady thing the temptation is to dance gasping on the shore, shouting that we are alive, till our forgotten savior has long since gone under. Or else sit quietly, sideswiped and embarrassed, mumbling that we really did know pretty much how to swim. But now that I see the wreck that could have been, without Miss Richey, I'm of a fearsome mind to throw my arms around every living librarian who crosses my path, on behalf of the souls they never knew they saved.

I reached high school at the close of the sixties, in the Commonwealth of Kentucky, whose ranking on educational spending was I think around fifty-first, after Mississippi and whatever was below Mississippi. Recently Kentucky has drastically changed the way money is spent on its schools, but back then, the wealth of the county decreed the wealth of the school, and few coins fell far from the money trees that grew in Lexington. Our county, out where the bluegrass begins to turn brown, was just scraping by. Many a dedicated teacher served out earnest missions in our halls, but it was hard to spin silk purses out of a sow's ear budget. We didn't get anything fancy like Latin or Calculus. Apart from English, the only two courses of study that ran for four consecutive years, each one building upon the last, were segregated: Home Ec for girls and Shop for boys. And so I stand today, a woman who knows how to upholster, color-coordinate a table setting, and plan a traditional wedding—valuable skills I'm still waiting to put to good use in my life.

As far as I could see from the lofty vantage point of age sixteen, there was nothing required of me at Nicholas County High that was going to keep me off the streets; unfortunately we had no streets, either. We had lanes, roads, and rural free delivery routes, six in number, I think. We had two stoplights, which were set to burn green in all directions after 6 P.M., so as not, should the event of traffic arise, to slow anybody up.

What we *didn't* have included almost anything respectable teenagers might do in the way of entertainment. In fact, there was one thing for teenagers to do to entertain themselves, and it was done in the backs of Fords and

Chevrolets. It wasn't upholstering skills that were brought to bear on those backseats, either. Though the wedding planning skills did follow.

I found myself beginning a third year of high school in a state of unrest, certain I already knew what there was to know, academically speaking—all wised up and no place to go. Some of my peers used the strategy of rationing out the Science and Math classes between periods of suspension or childbirth, stretching their schooling over the allotted four years, and I envied their broader vision. I had gone right ahead and used the classes up, like a reckless hiker gobbling up all the rations on day one of a long march. Now I faced years of Study Hall, with brief interludes of Home Ec III and IV as the bright spots. I was developing a lean and hungry outlook.

We did have a school library, and a librarian who was surely paid inadequately to do the work she did. Yet there she was every afternoon, presiding over the study hall, and she noticed me. For reasons I can't fathom, she discerned potential. I expect she saw my future, or at least the one I craved so hard it must have materialized in the air above me, connected to my head by little cartoon bubbles. If that's the future she saw, it was riding down the road on the back of a motorcycle, wearing a black leather jacket with "Violators" (that was the name of our county's motorcycle gang, and I'm not kidding) stitched in a solemn arc across the back.

There is no way on earth I really would have ended up a Violator Girlfriend—I could only dream of such a thrilling fate. But I was set hard upon wrecking my reputation in the limited ways available to skinny, unsought-after girls. They consisted mainly of cutting up in class, pretending to be surly, and making up shocking, entirely untrue stories about my home life. I wonder now that my parents continued to feed me. I clawed like a cat in a gunnysack against the doom I feared: staying home to reupholster my mother's couch one hundred thousand weekends in a row, until some tolerant myopic farm boy came along to rescue me from sewing-machine slavery.

Miss Richey had something else in mind. She took me by the arm in study hall one day and said, "Barbara, I'm going to teach you Dewey Decimal."

One more valuable skill in my life.

She launched me on the project of cataloging and shelving every one of the, probably, thousand books in the Nicholas County High School library. And since it beat Home Ec III by a mile, I spent my study-hall hours this way without audible complaint, so long as I could look plenty surly while I did it. Though it was hard to see the real point of organizing books nobody ever looked at. And since it was my God-given duty in those days to be frank as a plank, I said as much to Miss Richey.

She just smiled. She with her hidden agenda. And gradually, in the process of handling every book in the room, I made some discoveries. I found *Gone With the Wind*, which I suspected my mother felt was kind of trashy, and I found Edgar Allan Poe, who scared me witless. I found William Saroyan's *Human Comedy*, down there on the shelf between Human Anatomy and Human Physiology, where probably no one had touched it since 1943. But I read it, and it spoke to me. In spite of myself I imagined the life of an immigrant son who believed human kindness was a tangible and glorious thing. I began to think about words like *tangible* and *glorious*. I read on. After I'd read all the good ones, I went back and read Human Anatomy and Human Physiology and found that I liked those pretty well too.

It came to pass in two short years that the walls of my high school dropped down, and I caught the scent of a world. I started to dream up intoxicating lives for myself that I could not have conceived without the books. So I didn't end up on a motorcycle. I ended up roaring hell-for-leather down the backroads of transcendent, reeling sentences. A writer. Imagine that.

The most important thing about the books I read in my rebellion is that they were not what I expected. I can't say I had no previous experience with literature; I grew up in a house full of books. Also, I'd known my way

around the town's small library since I was tall enough to reach the shelves (though the town librarian disliked children and censored us fiercely) and looked forward to the Bookmobile as hungrily as more urbane children listened for the ice cream truck. So dearly did my parents want their children to love books they made reading aloud the center of our family life, and when the T V broke they took about two decades to get around to fixing it.

It's well known, though, that when humans reach a certain age, they identify precisely what it is their parents want for them and bolt in the opposite direction like lemmings for the cliff. I had already explained to my classmates, in an effort to get dates, that I was raised by wolves, and I really had to move on from there. If I was going to find a path to adult reading, I had to do it my own way. I had to read things I imagined my parents didn't want me looking into. Trash, like *Gone With the Wind*. (I think, now, that my mother had no real problem with *Gone With the Wind*, but wisely didn't let on.)

Now that I am a parent myself, I'm sympathetic to the longing for some control over what children read, or watch, or do. Our protectiveness is a deeply loving and deeply misguided effort to keep our kids inside the bounds of what we know is safe and right. Sure, I want to train my child to goodness. But unless I can invoke amnesia to blot out my own past, I have to see it's impossible to keep her inside the world I came up in. That world rolls on, and you can't step in the same river twice. The things that prepared me for life are not the same things that will move my own child into adulthood.

What snapped me out of my surly adolescence and moved me on were books that let me live other people's lives. I got to visit the Dust Bowl and London and the Civil War and Rhodesia. The fact that Rhett Butler said "damn" was a snoozer to me—I hardly noticed the words that mothers worried about. I noticed words like *colour bar*, spelled "colour" the way Doris Lessing wrote it, and eventually I figured out it meant racism. It was the thing that had forced some of the kids in my county to go to a separate

school—which wasn't even a school but a one-room CMS church—and grow up without plumbing or the hope of owning a farm. When I picked up *Martha Quest*, a novel set in southern Africa, it jarred open a door that was right in front of me. I found I couldn't close it.

If there is danger in a book like *Martha Quest*, and the works of all other authors who've been banned at one time or another, the danger is generally that they will broaden our experience and blend us more deeply with our fellow humans. Sometimes this makes waves. It made some at my house. We had a few rocky years while I sorted out new information about the human comedy, the human tragedy, and the ways some people are held to the ground unfairly. I informed my parents that I had invented a new notion called justice. Eventually, I learned to tone down my act a little. Miraculously, there were no homicides in the meantime.

Now, with my adolescence behind me and my daughter's still ahead, I am nearly speechless with gratitude for the endurance and goodwill of librarians in an era that discourages reading in almost incomprehensible ways. We've created for ourselves a culture that undervalues education (compared with the rest of the industrialized world, to say the least), undervalues breadth of experience (compared with our potential), downright discourages critical thinking (judging from what the majority of us watch and read), and distrusts foreign ideas. "Un-American," from what I hear, is meant to be an insult.

Most alarming, to my mind, is that we the people tolerate censorship in school libraries for the most bizarre and frivolous of reasons. Art books that contain (horrors!) nude human beings, and *The Wizard of Oz* because it has witches in it. Not always, everywhere, but everywhere, always something. And censorship of certain ideas in some quarters is enough to sway curriculums at the national level. Sometimes profoundly. Find a publishing house that's brave enough to include a thorough discussion of the principles of evolution in a high school text. Good luck. And yet, just about all working botanists, zoologists, and

ecologists will tell you that evolution is to their field what germ theory is to medicine. We expect our kids to salvage a damaged earth, but in deference to the religious beliefs of a handful, we allow an entire generation of future scientists to germinate and grow in a vacuum.

The parents who believe in Special Creation have every right to tell their children how the world was made all at once, of a piece, in the year 4,004 B.C. Heaven knows, I tell my daughter things about economic justice that are just about as far outside the mainstream of American dogma. But I don't expect her school to forgo teaching Western history or capitalist economics on my account. Likewise, it should be the job of Special Creationist parents to make their story convincing to their children, set against the school's bright scenery of dinosaur fossils and genetic puzzle-solving, the crystal clarity of Darwinian logic, the whole glorious science of an evolving world that tells its own creation story. It cannot be any teacher's duty to tiptoe around religion, hiding objects that might raise questions at home. Faith, by definition, is impervious to fact. A belief that can be changed by new information was probably a scientific one, not a religious one, and science derives its value from its openness to revision.

If there is a fatal notion on this earth, it's the notion that wider horizons will be fatal. Difficult, troublesome, scary— yes, all that. But the wounds, for a sturdy child, will not be mortal. When I read Doris Lessing at seventeen, I was shocked to wake up from my placid color-blind coma into the racially segregated town I called my home. I saw I had been a fatuous participant in a horrible thing. I bit my nails to the quick, cast nets of rage over all I loved for a time, and quaked to think of all I had—still have—to learn. But if I hadn't made that reckoning, I would have lived a smaller, meaner life.

The crossing is worth the storm. Ask my parents. Twenty years ago I expect they'd have said, "Here, take this child, we will trade her to you for a sack of limas." But now they have a special shelf in their house for books that bear the family name on their spines. Slim rewards for a parent's thick volumes of patience, to be sure, but at least there are no motorcycles rusting in the carport.

My thanks to Doris Lessing and William Saroyan and Miss Truman Richey. And every other wise teacher who may ever save a surly soul like mine.

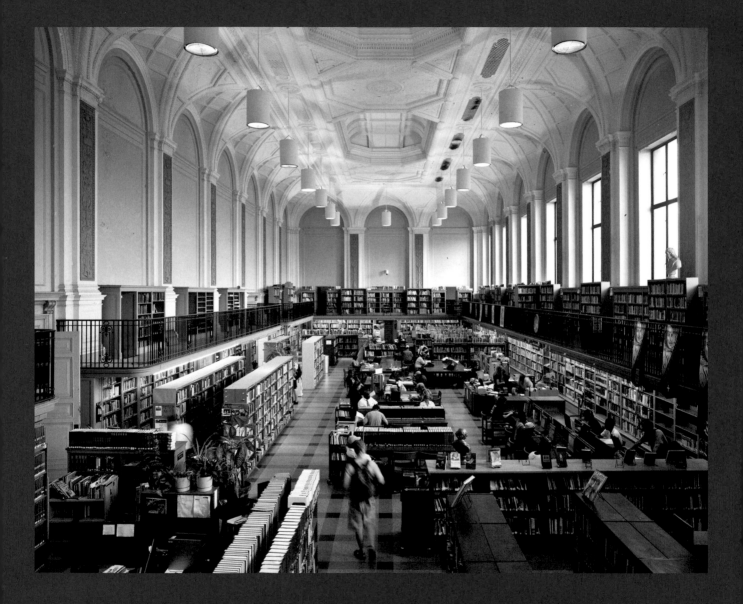

Reading room, Central Library, Philadelphia,
Pennsylvania, 2011

URBAN AND RURAL LIBRARIES

Libraries in large cities often are stunning works of architecture and can be great monuments to civic pride. They draw from the surrounding urban resources but also deal with many of the big-city problems. Some are great research centers, attracting people from all over the world to their specialized archives.

In small towns the public library may be the only noncommercial and nonreligious space where people can gather to meet neighbors and sustain the ties that create a sense of community. Libraries are among the few local government institutions that people interact with on a regular basis. They may be the *only* form of government that some like. I found many rural and small-town libraries to be completely filled with active library patrons.

Post Public Library, Post, Texas, 2011

**Boys and bikes, Truth or Consequences Public
Library, Truth or Consequences, New Mexico, 2011**

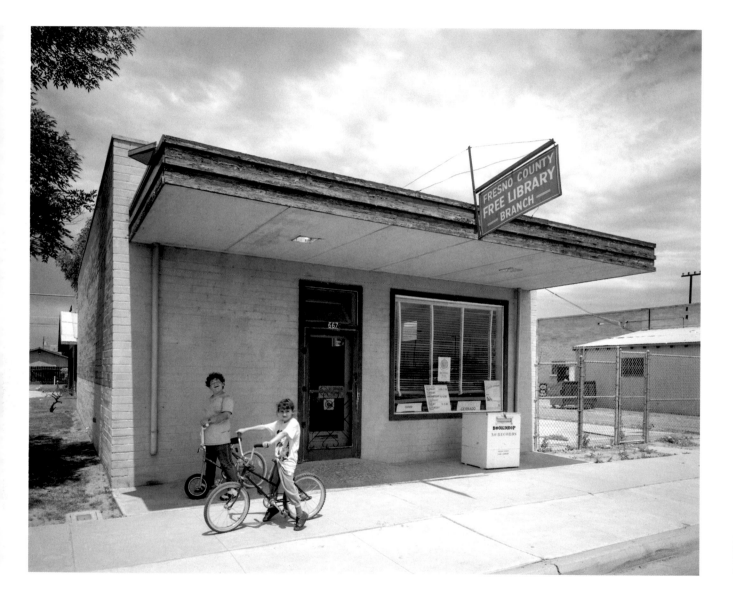

Fresno County Public Library,
Mendota, California, 1994

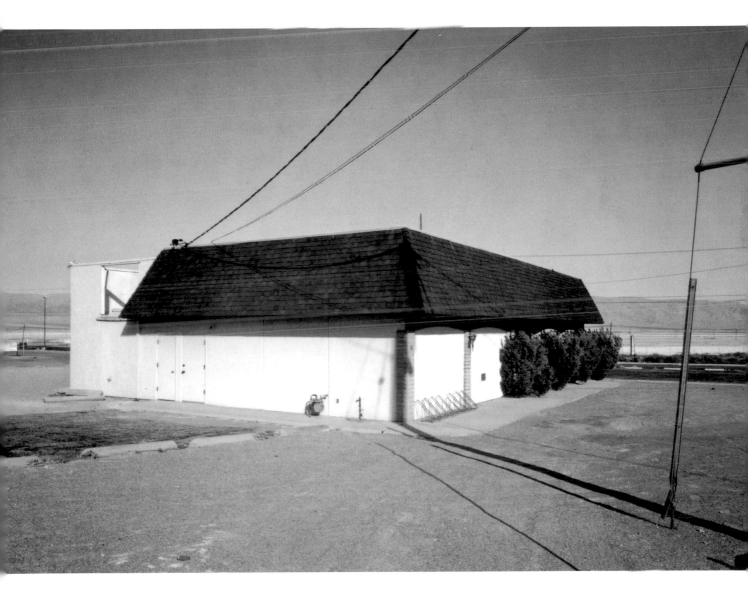

Trona Branch Library, Trona,
California, 1994

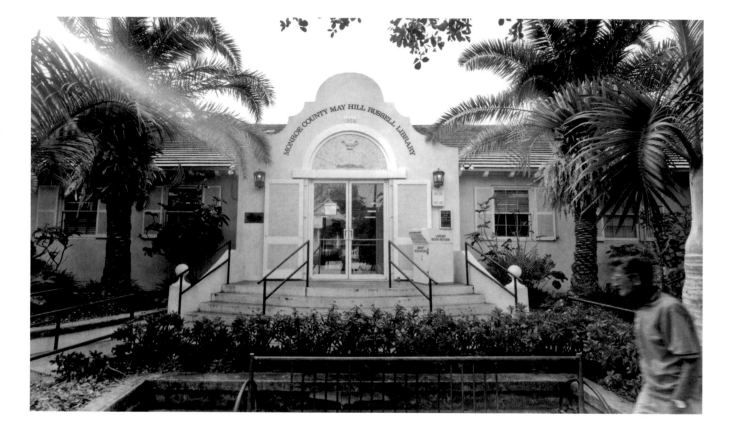

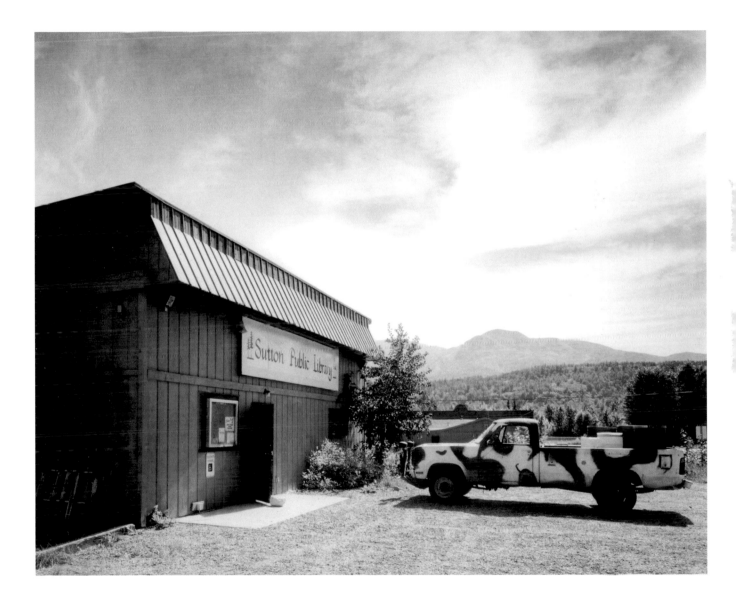

above

Jackson County Library, Kadoka, South Dakota, 2012 | Kadoka is known as the "Gateway to the Badlands," referring to the nearby Badlands National Park. It is located just north of the Pine Ridge Indian Reservation, one of the poorest areas in the United States. Pine Ridge is the location of the last Indian massacre by the US Army, in 1890 at Wounded Knee. It is also where a battle occurred between federal agents and members of the activist group the American Indian Movement in 1973. The reservation is larger than Delaware and Rhode Island combined, but there are no public libraries in Pine Ridge. Kadoka is approximately 80 percent white and 13 percent Native American and has one of the few libraries located near the reservation.

opposite

Back of Garwin Public Library, Garwin, Iowa, 2012

left
**Yosemite Valley Branch Library, Yosemite
National Park, California, 2008**

right
**Grand Canyon Community Library, Grand Canyon
National Park, Arizona, 2012**

opposite
**Library in snow, El Dorado County Library—
South Lake Tahoe Branch South Lake Tahoe,
California, 2010**

92 THE PUBLIC LIBRARY

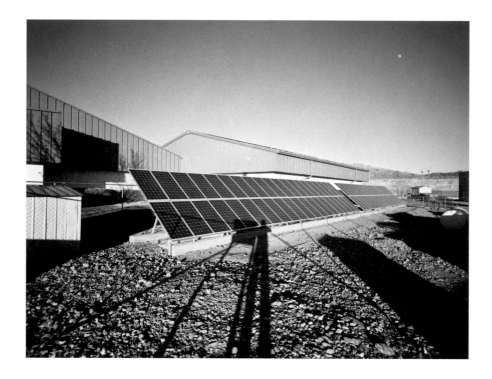

above

Solar panels, mine tailings, and Round Mountain Public Library, Round Mountain, Nevada,

2012 | Round Mountain is one of the most isolated communities in the lower forty-eight states. The area is classic basin and range country, with a mountain range on both sides of the town. The valley where Round Mountain is located is larger than the state of Rhode Island. The extensive tailings from the nearby gold mine dominate the landscape. After the California gold rush mines began to play out, prospectors moved east and discovered gold here in the 1860s. Although some ranching exists in the area, the town is almost wholly dependent on the mine for its existence. The first Round Mountain library originated more than thirty years ago when someone left a box of used books outside the sheriff's office. The new library was built in 1990 and now houses nearly forty thousand books.

opposite

Library, Death Valley National Park, California, 2009 | This remote library in a trailer is the only library for hundreds of miles. The roof is shaded to lessen the intense summer heat of the hottest place on earth.

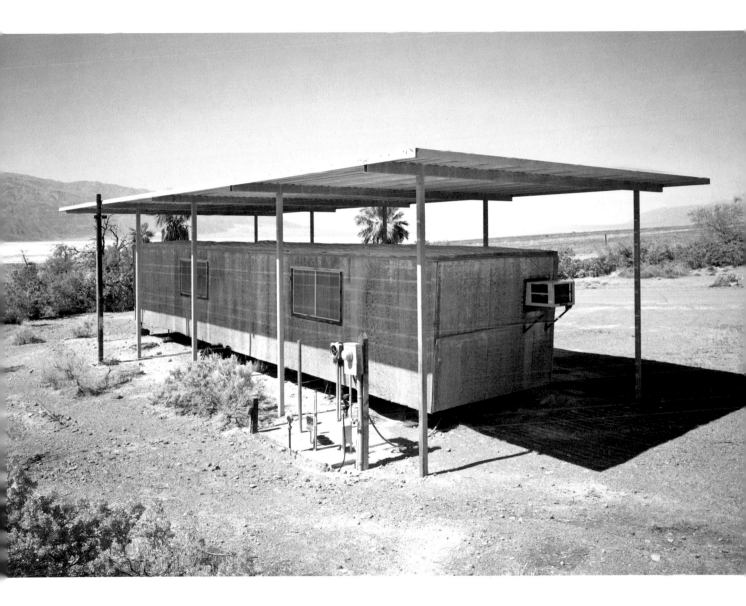

THE NORTHEAST NEVADA REGIONAL BOOKMOBILE

Kelvin K. Selders

I am the librarian for the Northeastern Nevada Regional Bookmobile. You could say that I'm the driver of a 2005 Kenworth filled with books, but the job requires more than driving.

Many of the places I stop at are very remote. "Remote" in Nevada means hours away from a town big enough to have a library. When the stop is closer to a town or a school library, we offer convenience to our patrons. It is much easier to bring a class of students to a library when it is parked beside the school. We also offer books and information on request.

The most essential aspect of my work is getting the books into young hands. The younger they start, the better. Children need to be exposed to print and books in many different capacities before they enter school. Most children can load a VCR tape or DVD and push "play" on the remote before they know "*a* is for *apple*." You will never get a diploma watching videos. You need to obtain reading skills to maximize your education.

* * *

RUBY VALLEY, NEVADA, 9:30 TO 10:30 A.M., EVERY OTHER MONDAY: It takes me an hour and twenty minutes to drive from Elko to the school at Ruby Valley. I cross the Ruby Mountains at Secret Pass. The road has many curves as it climbs through the pass. You can see a stream flowing far below, feeding the trees and shrubs.

The first patron I see at Ruby Valley is Ben Neff. He is a thirtysomething with special needs, and usually has about five watches on one arm. He collects uniforms and name tags and is usually wearing his latest one. Ben has a problem with stuttering, but he does one thing well: he can read! I park at the Neff Ranch in the summertime. A lot of the locals are related to the Neffs, so it's like meeting at Grandma's house. During the school year, I park at the school.

I often see patrons waiting for me when I get there, and when the steps are locked down and the generator is started, the schoolkids come out. Have you ever seen a child running to get a book? I have, and it makes me feel my job is worth more than the money I make. Parents with small children, even babies, come out at the same time as the schoolkids. In the six years I've been working at this

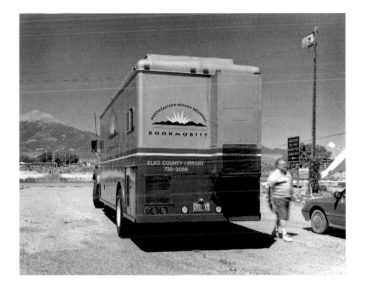

Northeastern Nevada Regional Bookmobile, Elko County Library, Baker, Nevada, 2000 | This bookmobile stops at twenty-nine locations every two weeks. It serves a vast area of rural northeastern Nevada, one of the most remote regions in the United States.

job, I have watched some of the kids grow up, and now they have their own library cards and are students at the school. While I am there, the patrons usually visit with each other and discuss books they have read. The Ruby Valley stop is more of a "family community" stop.

* * *

MONTELLO, NEVADA, 1:00 TO 2:00 P.M., EVERY OTHER MONDAY: It takes me an hour and a half to drive from Ruby Valley to just outside of Montello. I stop for lunch in a remote location—so remote that there's no radio signal, not even AM. I try to pull into the school at Montello five minutes early. There are patrons waiting.

When I started driving the bookmobile, this stop had three kids from the school, the teacher, and the lady next door. Now I have most of the adults in town, along with the schoolkids. Of all the places the bookmobile stops, Montello needs it the most. I can understand poverty— that's the way I grew up, although Montello is a lot smaller and poorer than where I came from. The children have a playground at the school—a swing and a slide. The adults have a small store and a bar. I heard they finally got a cell

tower up, so the better-off people can have a cell phone. If they have a computer, they get online through a dial-up connection. One patron with no power or water on the property hauls water and uses candles. This patron does have a portable CD/DVD player to watch movies and listen to books on CD, but can only use it in the pickup truck.

I noticed a problem on the bookmobile when I first started working. Some of the kids would leave without a book in their hands. This was happening because they did not have a library card and neither did their parents. It takes two weeks to get your library card, unless you go into the main library at Elko.

We started stocking paperbacks, which kids can check out without a library card. We have easy-to-read books for the smaller kids. Some are even chewable board books. We also have juvenile books for the older kids and adult paperbacks. Now no one has to leave the bookmobile without a book. That should be a librarian's primary job: to get books in people's hands.

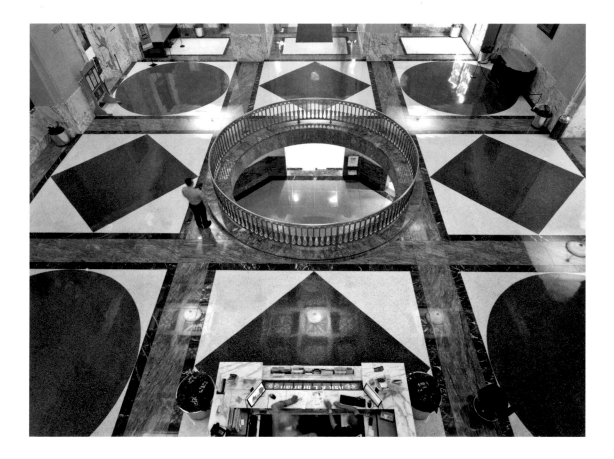

above

Main floor, Harold Washington Library Center, Chicago, Illinois, 2009 | The Chicago Public Library was created directly from the ashes of the 1871 Great Chicago Fire. After the fire, A. H. Burgess of London proposed an "English Book Donation," which resulted in the contribution of eight thousand books; private benefactors included Queen Victoria, Benjamin Disraeli, Alfred Lord Tennyson, Robert Browning, John Stuart Mill, John Ruskin, and Matthew Arnold. The first library opened in an abandoned water tower. In 1991 the Harold Washington Library Center, Chicago's new central library (named for the late mayor), opened to the public.

opposite
Entrance to the Central Library, Brooklyn, New York, 2009

Main Library, Detroit, Michigan, 2011 |
Designed by architect Cass Gilbert and partially funded by a gift from Andrew Carnegie, this stately Italian Renaissance–style library of glistening white marble was called the most beautiful building in Detroit when it opened in 1921, in a time when Detroit had the promise of being a world-class city. The sudden end of that dream left a mostly devastated city with a top-notch library. Detroit is the poorest large city in the United States and one of the most dangerous in the world. Inside the library, the grand hallways, the beautiful murals, and the great collections give a glimpse into another era. The mosaic above the entrance by Millard Sheets is titled *The River of Knowledge*.

Ceiling, Main Library, Detroit, Michigan, 2011

Armijo Branch Library, El Paso, Texas, 2011 |
This branch library is located one and one-half
blocks from the border between the United States
and Mexico.

opposite
Central Library, Los Angeles, California, 2008

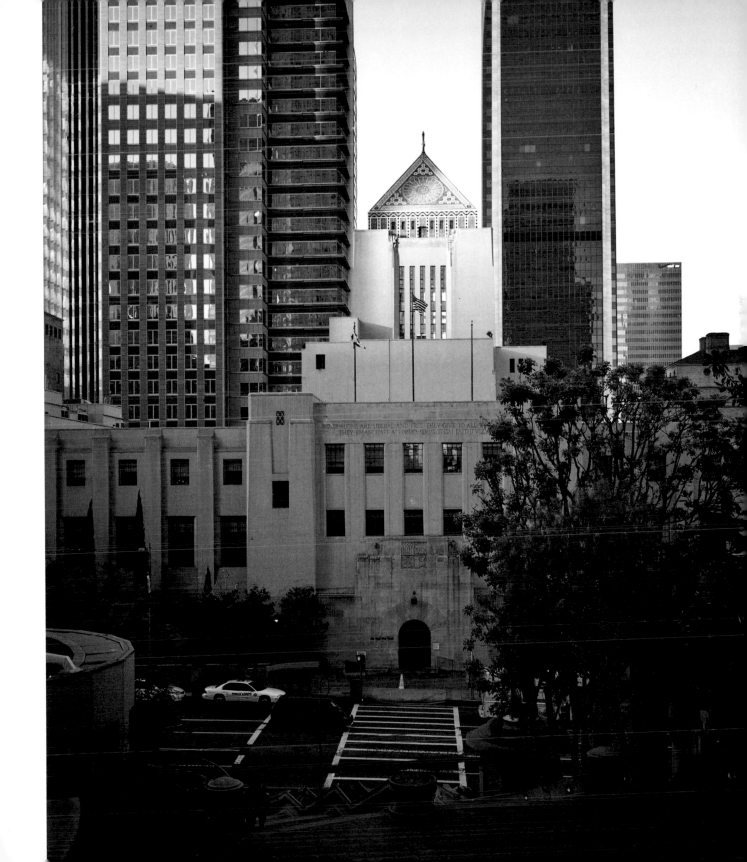

PRACTICING SEVA

Dorothy Lazard

I've been thinking about my grandmother a lot lately. When I was ten and living with her, she ran a board-and-care home for adults with psychological problems. As the only child in the household, I was recruited into service. I didn't know then about schizophrenia, obsessive-compulsive disorders, or any other ailment that might land someone in a "rest home" (as they were called back then), but I would certainly learn. My job was to look after this strange band of inmates while my grandmother ran errands or went to church. It was not hard work—just work I didn't want to do. Like cutting the crusts off of Phyllis's sandwiches. (Crusts sent her into conniptions.) Or making sure Akiko had her phenobarbital with each meal. Or allowing chattering Gloria to tread a rut in the hallway hardwoods. At the time this all seemed a waste of a good childhood.

Little did I know that I was learning patience, compassion, and stamina in that first unwanted position. All these skills have come in handy in my job at the Oakland main library. When I arrived there more than a decade ago, I was reintroduced to the same types of characters—the biochemically imbalanced, undermedicated, traumatized, inebriated, and drug-addled—only multiplied exponentially.

"How you say this name," a man at the desk asked me, squinting at the encyclopedia in his hand, his face a couple of inches away from the page.

"Kwame Nkrumah," I said.

"Kwame Barumba."

"No. Kwame Nkrumah."

The man looked at the entry again. "He was the first president of Ghana."

"Yes. That's right."

"How you say his name again? Kwame Mtumba."

"No. Kwame Nkrumah."

"Lumumba?"

"No. That's someone else." I pointed to each syllable of the name. "N-kru-mah. Kwame Nkrumah."

"Nkrumah."

"Yes!"

"Kwame Larumba."

I shrugged a little as he walked away from the desk. I usually let him go on like that because his inability to hold Nkrumah's name in his head is a minor issue. I know that toward the end of the month, when some demon has him by the collar, when his money—and, perhaps, his medication—has run low, he will come in, spewing a litany of

curses at some phantom tormentor. And one of us behind the desk will calmly say, "Sir, please watch your language," as if he is in control of his language or his mind or his life.

Other encounters are more sinister. Patrons threaten the library staff and each other with physical violence. They argue for physical space at the reading tables, extra time on public Internet terminals, and staff attention. When the doors open we welcome all manner of demands, crises, and strange behaviors.

Providing service to the homeless and untreated ill in California has been a steadily growing public-service challenge. Back in 1969 the passage of the Lanterman Act forced the closure of several large psychiatric hospitals. The argument for these closures was the high cost of maintaining them. The establishment of smaller, community-based facilities couldn't keep pace with the vast number of displaced patients. Over the next two decades, closures continued. As a result, the homeless and mentally ill population in urban areas exploded. Many patients returned to families ill-prepared to care for them. Others were arrested, becoming part of the prison system. And still others took their chances on the streets, seeking some form of independence. Many of them turned to self-medicating with drugs and drink or opted to live undiagnosed and unmedicated. Over the last thirty years, as a result, the public library has absorbed them.

As the last truly democratic space in America, where there are no entry fees, judgments, or barriers, public libraries offer a tour of our society's ills and ill. We library workers are, in practical terms, surrogates for shuttered schools, parks, hospitals, and homes. And we know we are hopelessly unqualified to treat what ails many of the people who pass through our doors. We are practicing a form of *seva*, the Sikh notion of selfless service. There is deterioration all around us, yet we carry on, providing service to the underserved, a patient ear to the unheard. We are acting as the last outposts of community space.

This is not a rosy picture, but neither is the situation. It's actually cause for alarm and action. Yet the public alarm seems to be on "pause." It's easy to find people who have abandoned their libraries altogether because of the number of homeless and mentally unstable individuals one finds there.

As a taxpayer-supported institution, the library doesn't have much choice but to let everyone in. The homeless and mentally troubled have as much right to be here as any Montclair nanny or Melrose hood-rat. Very hard decisions will have to be made if —and this is a very big *if*— ever there arises a movement to boot them out of the libraries. Sure, we have protocol for how to remove people from the library who cause disturbances: if they foul the floors, threaten us or other patrons. But we don't have the skills or resources to cure them. We can provide them with routine; a warm, relatively safe place; and a wealth of materials that, I hope, steadies their minds. By latching onto something—sports statistics, movie trivia, war histories, art books—they can anchor themselves to this shifting craft we call reality. At least for a while.

They ask us about UFOs. They boast of killing Lincoln. They shuffle rows of shelved books. They want to argue Bible passages and find out how much Indian blood they have. They tell us to hold all their calls and to reschedule their appointments. And we dutifully ride the wave of incomprehension, waiting for a moment of clarity to arrive so we can deliver the information they requested. Yes, I know—to believe that our efforts are not in vain is a form of magical thinking. But it's an occupational hazard. Librarians are trained to be polite, patient, and helpful, no matter who stands across from the reference desk. The most important thing is that we look them in the eye and take them seriously. Our work demands that we become dreamers, holding onto hope that our society can be better, that we *sevadars* affirm for our patrons that they are still part of this society, no matter how marginalized they have become in it. I was raised on the notion that the public library is a civilizing institution. And if our work calms someone's demons or teaches someone else how to treat the mentally ill with respect, then I am proud to be a part of the process.

SPREADING ENLIGHTENMENT

Luis Herrera

The public library of today, with its commitment to welcoming all who come through its doors, expresses truly American values, providing open and free access to information, spreading knowledge and enlightenment, and transforming the lives of its users.

Take the story of Leon Veal, who struggled with addiction, homelessness, and illiteracy before finding his way to the library. He explains:

> The day I came to the San Francisco Public Library to ask for help in learning how to read was one of the hardest days of my life. After entering a recovery program, I was encouraged to seek help from the [library's] adult literacy program, and my life began to turn around. I was paired with a tutor whom I worked with for two years.... Eventually came the day when I was able to read a whole book. I was forty-four years old, and reading that book was the greatest thing that had ever happened to me.

Today Mr. Veal is an employee of the San Francisco Public Library (SFPL), the same institution that once intimidated him. He provides neighborhood outreach as a staff member of Project Read, an initiative that spreads the word about the library's literacy programs and engages new tutors and literacy learners.

Visit a public library today, and you will see a hub of activity that involves far more than just reading. Libraries have successfully moved into the modern age by providing access to a broad range of digital and multimedia tools. Across the nation, public libraries are the number one point of online connection for people without access to the Internet at home, school, or work. At the SFPL, our computer labs thrive as drop-in resource centers for job seekers and small-business entrepreneurs. Librarians lead workshops to teach basic computer skills (in Cantonese, Mandarin, Japanese, Spanish, and Russian) and help avid readers of all ages download free library ebooks onto tablet computers and other personal devices.

Of course, the SFPL's literacy mission remains as critical as ever, and we offer assistance and a range of programs for our diverse, multilingual population. On any given day, children may be enjoying a rock concert in the library's auditorium, while teens are learning DJing and moviemaking skills in the teen center. And while the

conference room hosts a course for seniors who want to bolster their memory skills, the library for the blind provides space for a weekly yoga class. A vitally important early-literacy effort ensures that every branch hosts weekly story times for infants and toddlers and their caregivers, preparing our youngest patrons for more formal preschools and kindergartens.

Libraries are more relevant than ever. They are places for personal growth and reinvention, places for young and old to seek help in navigating the information age, gathering places for civic and cultural engagements, and trusted places for preserving culture. While the technology for accessing library materials has changed, and will continue to change, the library's mission to gather and inform will not. Perhaps no other place so embodies the American values of democracy and freedom of expression. This venerable institution represents what we as a society should never take for granted: the freedom to read, the freedom to choose, and the freedom to share ideas.

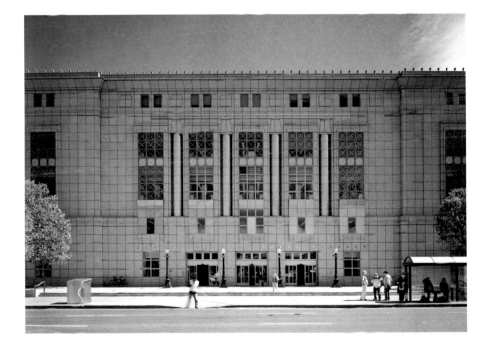

Entrance to Main Library, San Francisco, California, 2008 | Early plans for a new library were put on hold after the 1906 San Francisco earthquake, which destroyed about forty thousand volumes, nearly 25 percent of its holdings. The old main library, which was damaged in the 1989 Loma Prieta earthquake, was rebuilt as the new Asian Art Museum. This new main library was completed in 1995. This library is unique in having a full-time social worker on staff to help direct people in the library to appropriate government assistance.

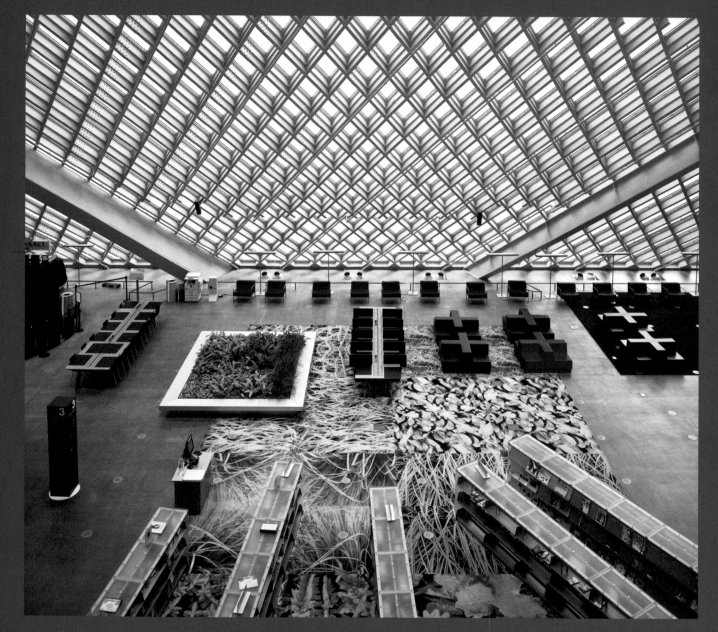

Community room, Central Library, Seattle,
Washington, 2009

CHAPTER FIVE

ART AND ARCHITECTURE

———

Library architecture spans the full spectrum from the plain and utilitarian to the spectacular and over-the-top. Some libraries are designed to be very functional in their mission of dispensing books and information. Others can be seen as monuments to the patron who endowed the library. Many are themselves works of art. Occasionally the architecture of a public library can be an eerie reminder of better times, before its local economy crashed. Sometimes these many conflicting purposes can clash.

Libraries can also be the repositories of great art, ranging from pieces that were locally produced or that reflect the identity of the local community to work created by internationally renowned artists. Some art comes from the collections of local donors; often it is an exuberant expression of local pride or ambition.

Main Library, Duluth, Minnesota, 2012

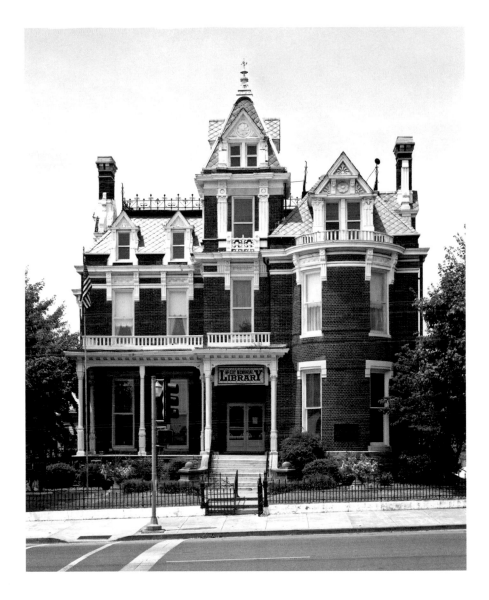

McCoy Memorial Library, McLeansboro,
Illinois, 2012

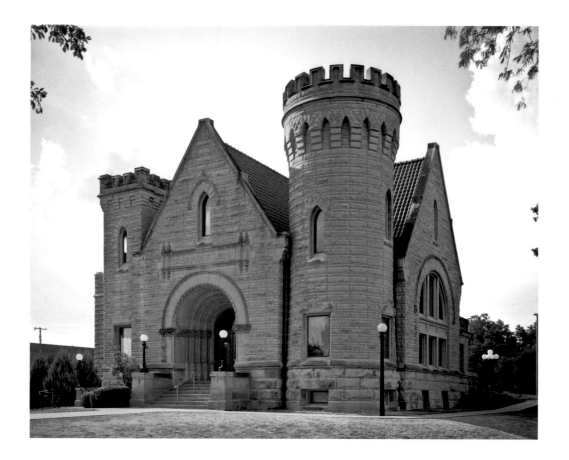

Brumback Library, Van Wert,
Ohio, 2011

Millicent Library, Fairhaven, Massachusetts, 1994 (diptych) | Mark Twain's letter to the Millicent Library, 1894:

I am glad to have seen it. It is the ideal library, I think. Books are the liberated spirits of men, and should be bestowed in a heaven of light and grace and harmonious color and sumptuous comfort, like this, instead of in the customary kind of public library, with its depressing austerities and severities of form and furniture and decoration. A public library is the most enduring of memorials, the trustiest monument for the preservation of events or a name or an affection; for it, and it only, is respected by wars and revolutions, and survives them. Creed and opinion change with time, and their symbols perish; but Literature and its temples are sacred to all creeds, and inviolate. All other things which I have seen today must pass away and be forgotten; but there will still be a Millicent Library when by the mutations of language the books that are in it now will speak in a lost tongue to your posterity.[23]

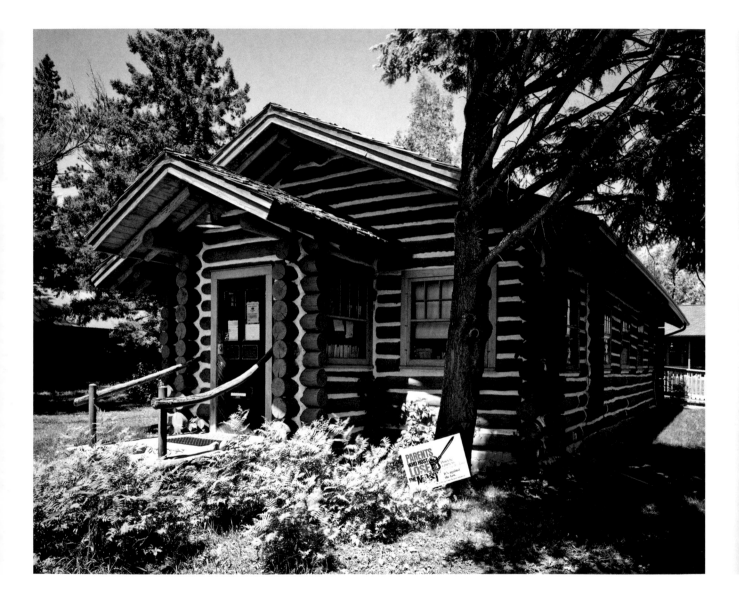

**Forest Lodge Library, Cable,
Wisconsin, 2012**

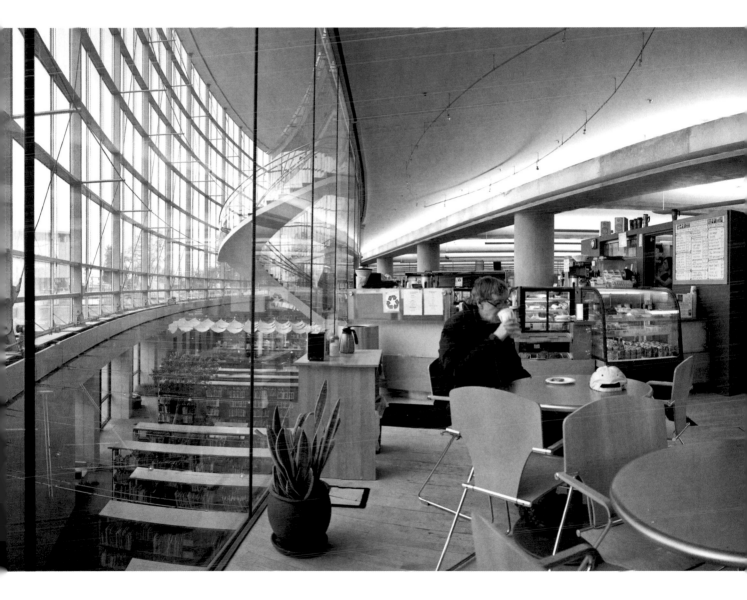

Coffee shop in library, Main Library,
Salt Lake City, Utah, 2010

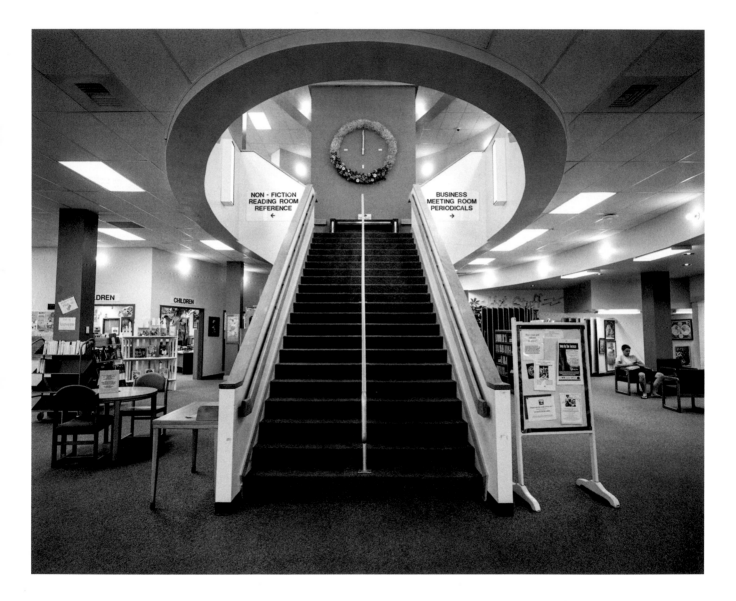

above

**Stairway in Midland County Library,
Midland, Texas, 2011**

opposite

**Interior dome, Central Library, Milwaukee,
Wisconsin, 2012**

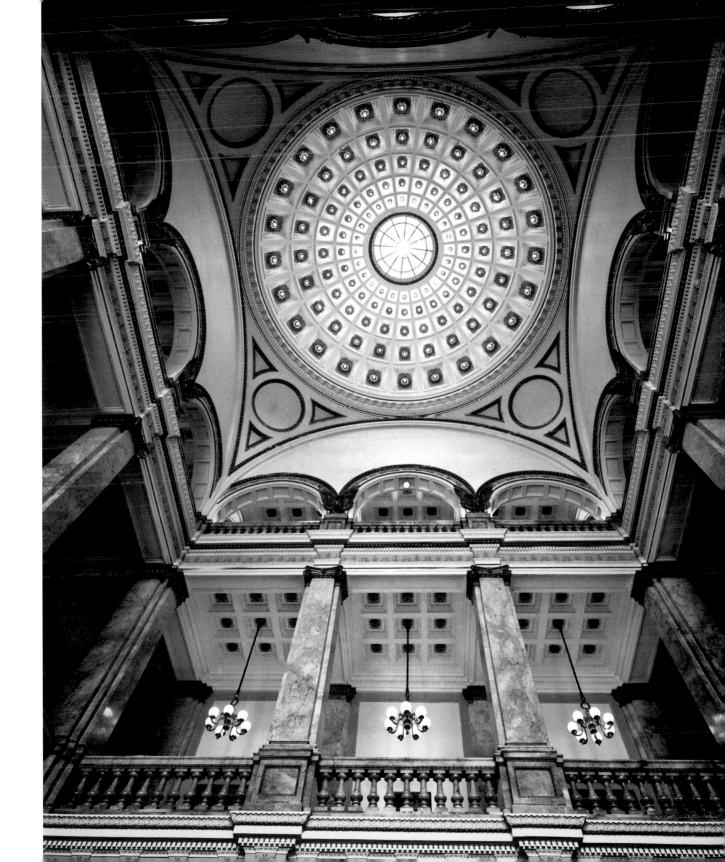

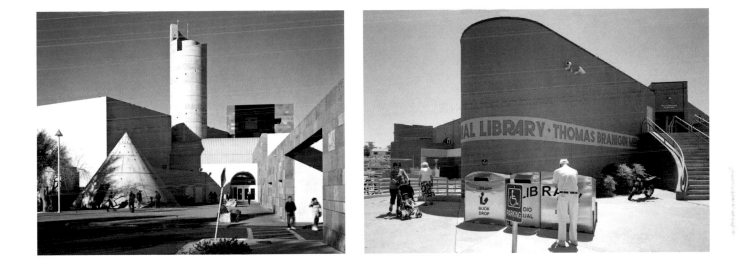

opposite
**Frank Lloyd Wright-designed Civic Center
Library, San Rafael, California, 2009**

right
**Thomas Branigan Memorial Library, Las Cruces,
New Mexico, 2011**

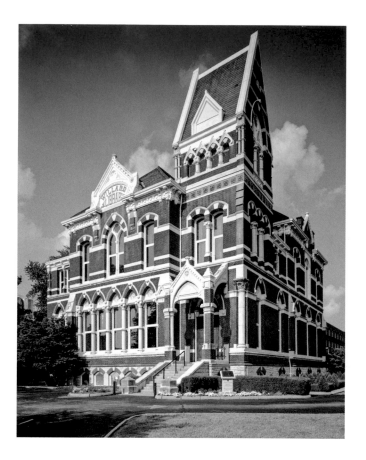

Enoch Pratt Free Library, Orleans Street Branch
Library, Baltimore, Maryland, 2011

View from main library of the Wasatch Mountains,
Salt Lake City, Utah, 2010

Sculpture, cliffs, and Springdale Branch Library,
Springdale, Utah, 2012

Reading sculpture inside the Fargo Public Library,
Fargo, North Dakota, 2012

Moose Pass mural by Claire Robinson, Moose Pass
Public Library, Moose Pass, Alaska, 1994

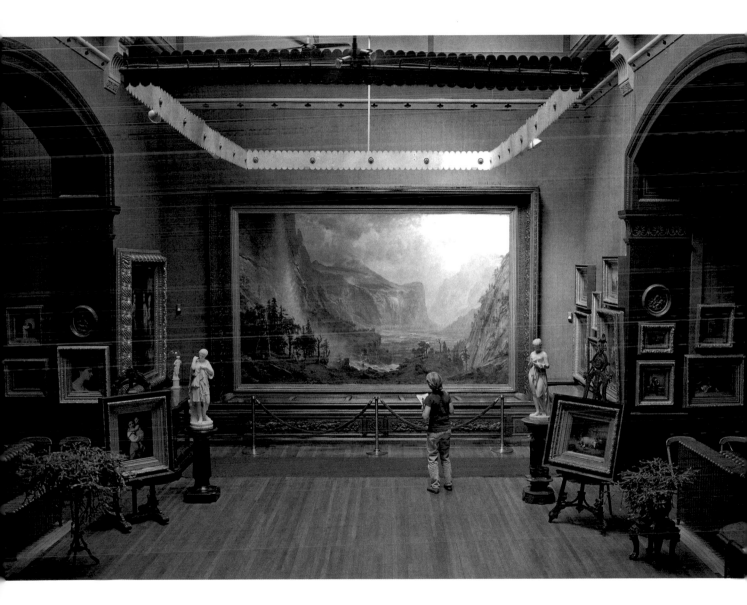

St. Johnsbury Athenaeum Library, St. Johnsbury, Vermont, 2001 | The painting of Yosemite Valley in California, titled *The Domes of Yosemite*, is by the famous nineteenth-century German American artist Albert Bierstadt.

Book mural on parking structure near Central Library, Kansas City, Missouri, 2012 | This "community bookshelf" piece was commissioned by the city and was realized by the design firm Dimensional Innovations. The selection of books mounted on the parking structure was chosen by a public vote to best represent the city.

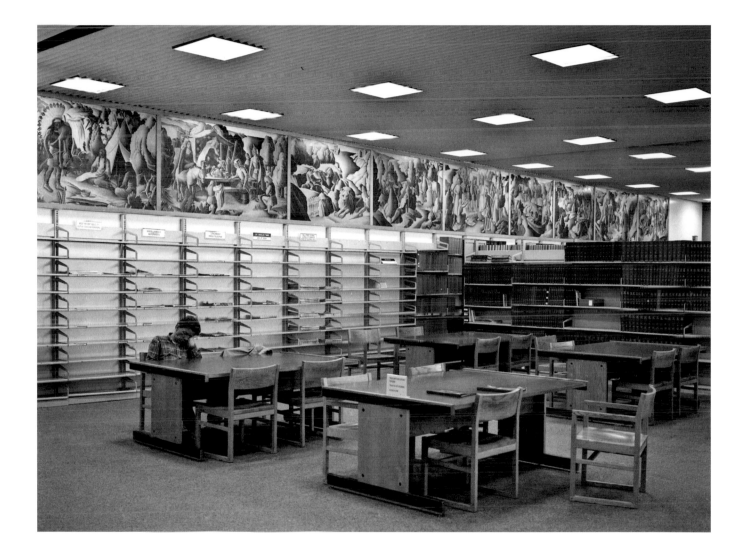

New Deal-era paintings, Long Beach Public Library, Long Beach, California, 2005 | Suzanne Miller painted the library's WPA mural in 1937. Librarians helped save this magnificent children's mural from destruction when the old main library was torn down in the 1970s.

Sculpture at the Main Library, Salt Lake City, Utah, 2010 | This hanging public art piece by Ralph Helmick and Stu Schechter, entitled *Psyche*, consists of nearly fifteen hundred small sculptures of books and butterflies forming the shape of a head.

above

Fountain of Knowledge by Elsa Flores, Biblioteca Latinoamericana Branch Library, San Jose, California, 2012

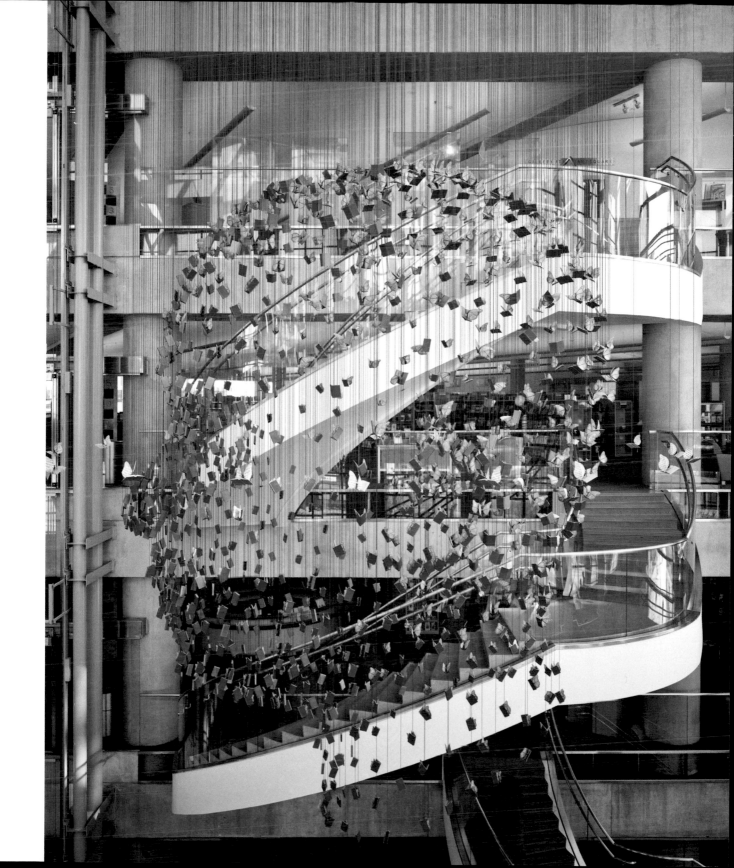

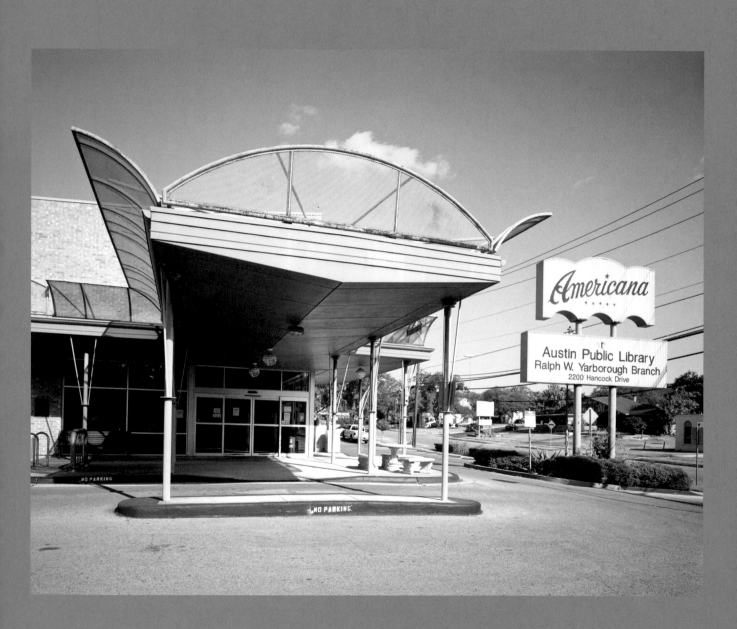

Yarborough Branch Library, Austin, Texas, 2011 | This branch library is housed in the former Americana Theater building.

EVOLVING LIBRARIES

———

Public libraries in America have always had to adapt to new situations and circumstances. In small towns they often share space with other branches of local government. Some are intentionally built that way, while others evolve as communities change. Some libraries share space with shopping malls, while others coexist with opera houses. I photographed many transformed libraries, including ones that used to be banks, Civil War hospitals, jails, churches, railroad stations, gas stations, fish markets, nightclubs, and Indian trading posts.

ENRICHED BY WHAT WE SHARE: A GREEN PERSPECTIVE ON THE PUBLIC LIBRARY AS A CULTURAL COMMONS

Chip Ward

I am a career librarian who is better known as a conservation advocate, a so-called environmentalist. Those seemingly disparate callings have taught me the same lesson: from tooth and bone to eye and mind, the commons shapes us through and through.

The ecological sciences reveal to my modern mind what our ancestors learned firsthand the hard way and what most of us today still sense intuitively: our lives are embedded in nature. Food is a synthesis of sunlight, soil, and rain. Soil is leaf, limb, root, stone, carcass, carapace, and flower. We drink from a watershed. The air we breathe belongs to all, knows no boundaries, cannot be captured or sold. The salt of earth and sea is tasted in a teardrop. The warm energy of a distant star pulses through my hands. The world that becomes us was here long before we were born and will live on long after we die.

We live in a fluid world where, for better or worse, what goes downwind or downstream also goes within, carried by blood, nesting in bone, and experienced each waking day. Using the term *environmentalist* to describe the ecologically literate misses the point. We are *embodimentalists*. We embody our common environment.

Although we pridefully contend we are individuals first and foremost, our culture is also a commons that shapes who we are. After all, who are we without language, knowledge, stories, morals, norms, identity, technology, education, literature, music, humor…? I, too, cherish my individuality and uniqueness, but I know I have been molded by my community and a culture that is created collectively.

There is no better place to survey the rich gifts our cultural commons offers us than the public library. The public library is the civic commons that contains the cultural commons in all its wide-ranging diversity.

Living systems are never static but are always in play, driven by appetite, opportunity, adaptation, competition, synergy, and reciprocity. Nature is loaded with disturbances—floods, fires, storms, droughts, earthquakes,

avalanches—so change is constant. When an ecosystem is under stress, having numerous possibilities for reconfiguration can be the difference between health and failure. Biodiversity is a key measure of an ecosystem's viability because it translates into options and possibilities when turmoil happens.

A robust democratic system, like a vital ecosystem, requires a diverse mix of options when faced with change, as well as credible feedback on the choices we make together. Just as biodiversity gives disturbed or distressed landscapes many options for reconfiguration and healing, cultural diversity is a resource for resilience in a society racked by contradictory responses to the dysfunction and disparity we are experiencing in this age of chaos and transformation. When we enable diverse perspectives, talents, and knowledge to be shared, we create resources for solving problems creatively and flexibly. We can survive our past mistakes. When citizens within a community can learn from one another openly and safely, we lean toward wholeness.

American culture is a case study in the creative power of mixing people with varied knowledge and traditions. Our staple foods, such as corn and potatoes, and even our democratic form of government were borrowed from Native Americans. African slaves carried to America the roots of beloved American musical forms like the blues and gospel, which evolved into rock 'n' roll, jazz, country, and hiphop. A dynamic mixing of cultures has given Americans our famous openness to innovation. Our characteristic sense of optimism is also an expression of our abundant possibilities. America is exceptional because of its cultural diversity, which, like biodiversity, makes life interesting and beautiful.

American public libraries have long provided venues for self-improvement and assimilation—many were built with funds from Andrew Carnegie, an immigrant who understood the value of education and the potential for public libraries to help turn-of-the-century immigrants learn, participate, and succeed. Libraries still offer basic literacy but are also bridging digital divides by teaching computer skills and making databases, software applications, and Internet access available on public workstations. And the role of the public library in making information available remains central. But it is in providing public space for civic encounters that the public library can empower citizens to be full participants in a democratic society.

We enjoy a democratic culture—not because we are like-minded, but because we realize that although we are not like-minded, we have common interests and needs that trump our disagreements. The mission of the Salt Lake City Public Library includes facilitating public discourse and debate. And we understand that for challenges to be overcome, for differences to be expressed and assessed, for perspectives to be fleshed out, for credible information to emerge, and for common ground to be discovered, the public needs a safe, inviting, even inspiring place to do that. A library is a place where dissent is respected, tolerance is shown, and open-minded behaviors are modeled. Otherwise, we lob our disagreements at one another like bombs from behind walls where we harden and become brittle. Or we get caught between feuding fanatics. Our intention, then, has been to create what Utah's Terry Tempest Williams calls "an open space for democracy."

When the new main library in Salt Lake was being planned, we knew we needed to include places to meet formally—rooms that would accommodate just a few or entire conferences. We wanted to provide plazas, indoors and out, for festivals and rallies or for people to just sit and stroll and watch. A rooftop garden could accommodate weddings, anniversaries, and fund-raisers. We wanted an art gallery to showcase local talent. There should be a waterfall and wading pool where small children could play. We built a children's library with theme rooms ("Grandma's Attic" and the "Crystal Cave") that would stimulate the imagination of our youngest patrons and give them lasting memories of childhood trips to the library. We added a coffee shop and restful places for conversation. The auditorium could handle everything from poetry slams and music recitals to lectures, panels, and films. A public-radio station

was invited to set up a branch inside so that programs could be broadcast and shared by those who couldn't attend. A teen library, the Canteena, was designed for social interaction, with booths where kids were allowed to talk and laugh.

Many of the library's features were suggested by the dozens of stakeholder groups we identified and invited to participate in the planning and design. For instance, when asked what they liked about our current library facilities, many patrons described the fireplace room in one of our branch libraries. So we put a fireplace on every floor. Even after a campaign to fund the new library resulted in a successful bond election, we continued to bring groups of stakeholders in to tour the construction site and see the progress their tax dollars were generating. It was their library, and we wanted them to feel their ownership.

Governance of the library was also participatory. All staff members, even part-time aides, were consulted about every aspect of the library's operation, from its guiding mission to its budget, policies, and technology. Dozens of committees sorted through the data. Although that form of participatory democracy can be slow at times and confusing, too, it also resulted in much innovation and intense loyalty to a common purpose.

One practice that symbolized the inclusive and participatory nature of our organizational culture was called "Name in the Hat." Once a year all employees were invited to put their names in a pool of those who wanted a change in their work location, job duties, and status. Although it was understood and accepted that not everyone's wishes would be met, we regularly moved about fifty people a year (out of a staff of three hundred). The conventional wisdom is that such mobility is disruptive because workers need to reorient to new locations or learn new tasks and skills. But over the long run, "Name in the Hat" made us stronger, more cohesive, and smarter. We ended up with staff members who had multiple skills, could easily substitute for each other, and were well aware of how all the parts of the library functioned together.

When the library was finally opened, visitors saw the sweeping architecture and the way light filled up and danced in the generous open spaces. They admired the art and the unique features like the glass elevators. Library Square became, as we hoped, a destination for those who simply wanted to experience the grandeur of such a public place while encountering each other. But what most visitors didn't see is that the library is not just a building or plaza: it was created by their own ideas, their own aspirations, and by people who were dedicated to the ideal of the commons and who practiced what they preached.

A controversial expression of the public library's ideals is the presence of transients in most public libraries today. Chronically homeless people regard the public library as a de facto daytime shelter. Understandably, they gravitate toward a place that is warm, dry, safe, inviting, and entertaining. Many of them are troubled, and their behavior is disturbing. Library patrons regularly complain, and staff grow weary of dealing with "street people." But even disturbing information is useful feedback.

When the mentally ill whom we have thrown onto the streets haunt our public places, their presence tells us something important about the state of our union, our national character, our priorities, and our capacity to care for one another. That information is no less important than the information we provide through databases and books. The presence of the impoverished mentally ill among us is not an eloquent expression of civil discourse, like a lecture in the library's auditorium, but it speaks volumes nonetheless.

The belief that we are responsible for each other's social, economic, and political well-being, that we will care for our weakest members compassionately, should be the keystone in the moral architecture of a democratic culture. It is not enough to say it. In the public library we try to do it by creating a respectful and inclusive environment where we can practice that complex and crucial dance of mutuality that is only possible in a safe and open civic commons.

Nature is amazingly reciprocal and integrated—rich with feedback loops, synergy, and the constant exchange

of information and energy. Societies that encourage feedback and provide the means to exchange knowledge and ideas easily are likewise more adaptable and resilient than those where knowledge is a privilege and ideas are constricted and controlled. We can continue to use concepts and vocabulary rooted in sociology, politics, and economics to explain why libraries are important. But the earth's natural operating systems also show how life is shaped by an inclusive symbiosis, by open opportunity, rich diversity, and the easy exchange of energy and resources.

We are woven, each individual like a bright strand, in a tapestry that is both ecological and cultural. We are influenced and enriched by what we share. And in the case of the public library, we are more than enriched: we are empowered.

Library/Post Office, Scott Bar, California, 2009 | Librarian/Postmaster Genetta Clark wrote about her daily duties and problems: "Siskiyou County libraries are under a terrible crunch. At one time a few years ago the retiring head librarian was asked to make budget cuts for the next year.... A few weeks later, she called and said she was closing the Scott Bar Library. She had someone come and get the books that she wanted back at the main library. They took the computer and turned off the Internet. End of story? No!...Customers were in an uproar.... So we went to the board of supervisors and told them our story....They could not believe that a County office that was the only visible County facility free to the public had been closed. They reopened the Scott Bar Library, we got our books and scanner back, and...have continued on our way serving the communities."

Vershire Community Library, Hostel, and Vermont
Shop, Vershire, Vermont, 2009

Seligman Public Library, Duane Corn
Municipal Complex (former strip mall),
Seligman, Missouri, 2011

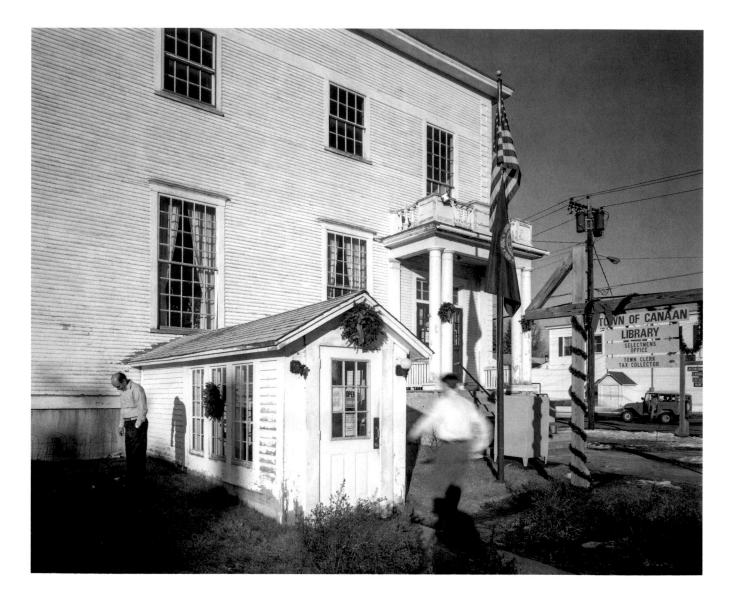

Town of Canaan Library and City Hall, Canaan,
New Hampshire, 1994

Rico Public Library and City Hall, Rico,
Colorado, 2012

**Woman in charge of Post Office/Library, Tuscarora
Branch Library, Tuscarora, Nevada, 2009**

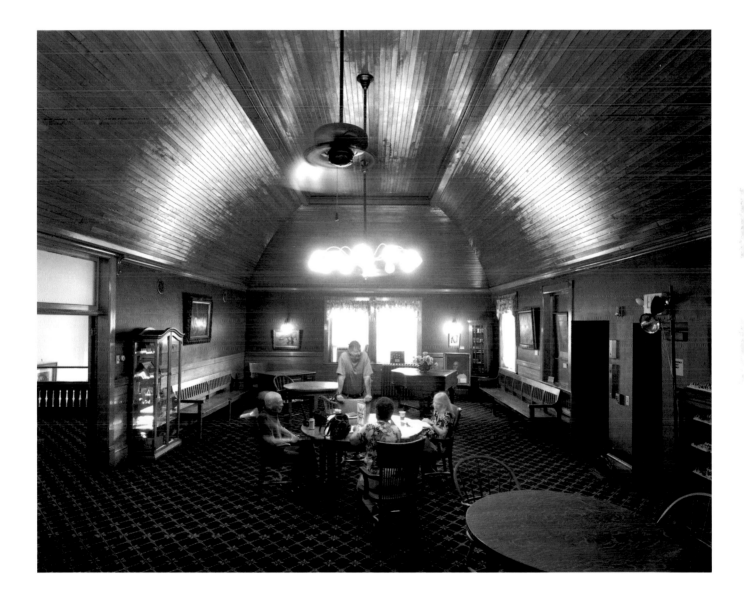

Meeting in Goodrich Memorial Library, Newport,
Vermont 2009

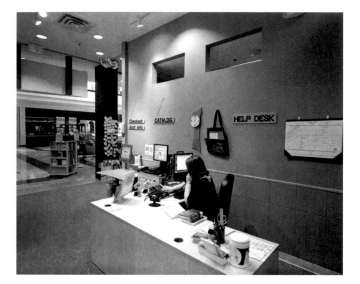

left

Galleria Library, Galleria at Sunset Mall, Henderson, Nevada, 2012 | The Galleria Library was located in the Sunset Mall in the city of Henderson just outside Las Vegas, Nevada. The librarian explained that this small library was an attempt to bring a library to the people of this community. Some patrons had difficulty understanding a nonprofit space in a for-profit commercial mall, so the library had to sell a few books to satisfy those patrons' need to buy something. This branch of the Henderson Library system closed in 2012.

right

Haskell Free Library and Opera House on border, Derby Line, Vermont-Quebec, 2005 | The Haskell Free Library and Opera House is both a functioning public library and an opera house, open to Americans and Canadians. A library patron can enter the turn-of-the-century building in Vermont and check out the books—in English or French— in Quebec. The librarian may be either a citizen of the United States or Canada, or both (and probably bilingual). The library was originally built astride the United States / Canada boundary as an expression of international cooperation in 1904.

opposite

Letts Public Library and community room, Letts, Iowa, 2012

Lynch Public Library, Lynch, Nebraska, 2012

Shepherdstown Public Library, Shepherdstown, West Virginia, 2011 | Built in 1800, this building has been home to a market, the fire department, a Civil War hospital, a butcher shop, a school, an Odd Fellows hall, and the local jail. Opened as a library in 1921, the building is West Virginia's longest continuously occupied library building.

Caliente Branch Library in former Union Pacific
railroad station, Caliente, Nevada, 2012

Library, Weeping Water, Nebraska, 2012 |
This structure was originally built as a church before becoming a public library. When I took this photograph, the old limestone rock walls of the now-closed library exuded rust-colored stains, making the building look as though it were weeping blood.

left

Glendive Public Library in former bank, Glendive, Montana, 2012

right

Former gas station, now Halls Public Library, Halls, Tennessee, 2011

opposite

Jefferson Market Library, New York, New York, 2010 | This building was originally built as a courthouse and later served as a women's prison. It was slated for demolition in 1959, but Greenwich Village community members, including Lewis Mumford, E. E. Cummings (who lived across the street), and actor Maurice Evans, rallied to save the building. It was converted into a library in 1967.

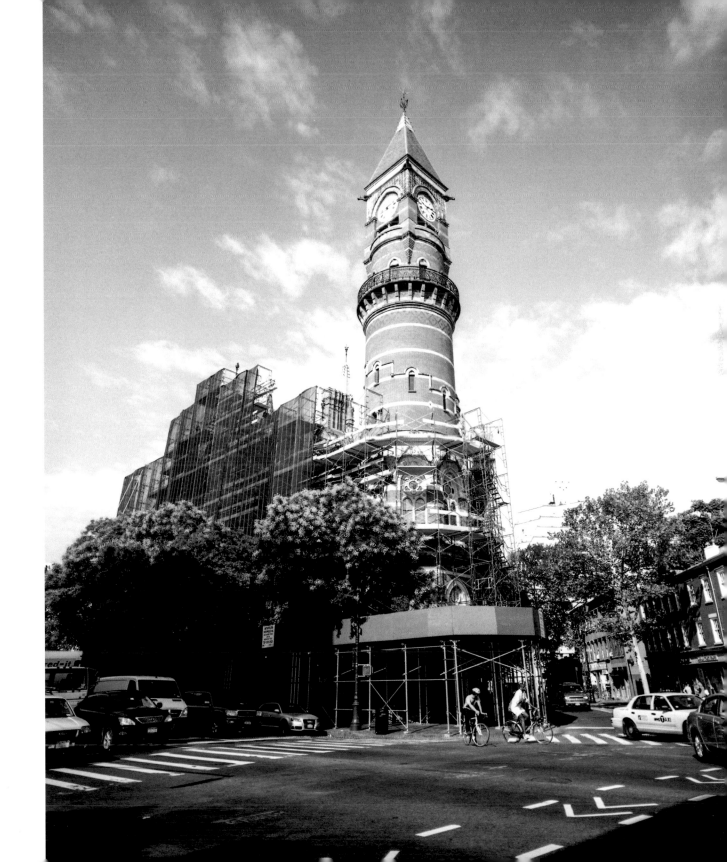

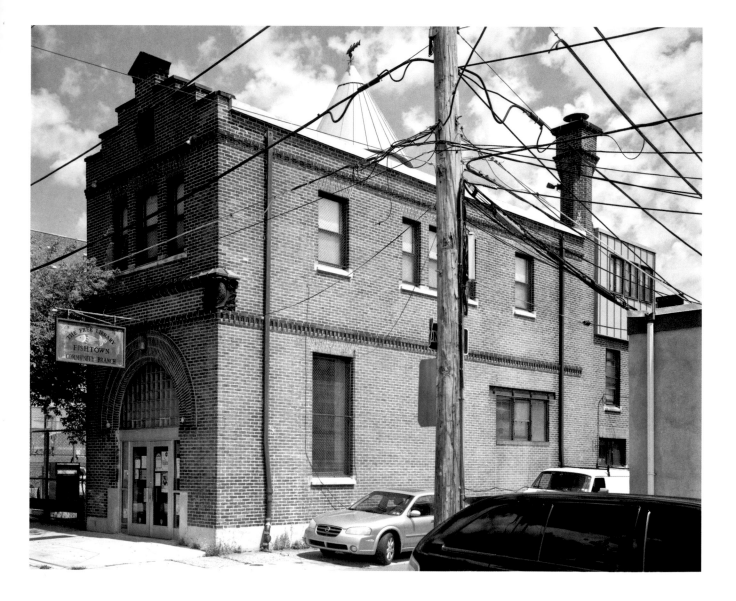

opposite
Fishtown Community Branch, Free Library of Philadelphia, Philadelphia, Pennsylvania, 2011 | This library is located in a former stable and fire station. As I photographed outside the library, a man came over and explained that his mother helped save it from becoming a parking lot for the nearby police station. When this branch was finally rededicated, the mayor of Philadelphia came to his mother's house and offered to give her a ride to the ceremony in his limo. She refused, choosing to walk the one block instead.

left
Felton Branch Library in former church, Felton California, 2009

right
Vault and door, Central Library, Kansas City, Missouri, 2012 | After remodeling the former First National Bank, the central library moved into this building in 2004. The old bank vault, part of the 1925 bank addition, contains walls of steel and reinforced concrete and a thirty-five-ton steel door. It has been converted into a movie theater, showing a variety of films in partnership with local film groups.

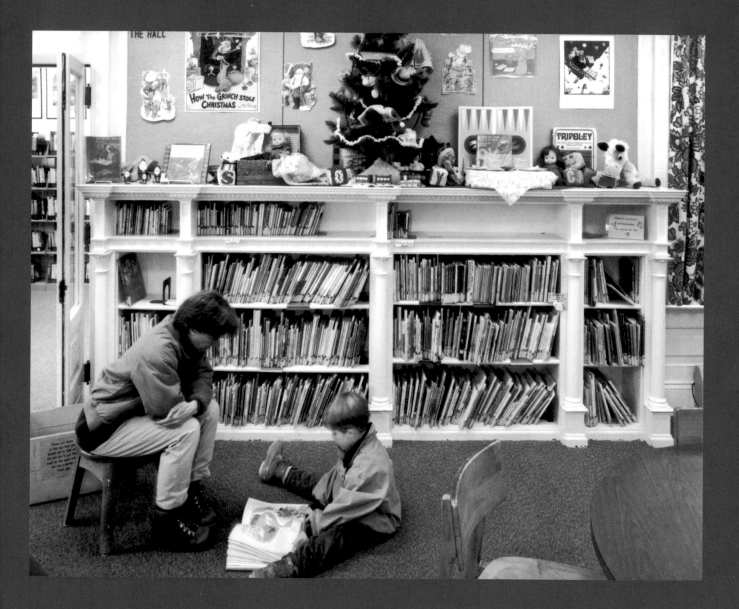

Early reading, Richards Free Library, Newport,
New Hampshire, 1994

LITERATURE AND LEARNING

———

Some libraries are closely connected to important literary figures. Many writers got their start in a library, and some, like Richard Wright, incorporated the library into their literature.

The traditional mission of the library has been to help people gain access to information and ideas. Literacy campaigns continue to play a central role in the library's mission, as well as efforts to teach computer skills and other technologies. But the very definition of a library is changing. While local governments run most public libraries, more people are beginning to create their own alternatives. I selected a few examples of grassroots efforts to supplement our publicly supported library system, including a seed-lending library and a tool-lending library. As Isaac Asimov wrote, "The library was the open door to wonder and achievement." Public libraries continue to be that open door for countless Americans.

LIBRARY DAYS

Philip Levine

I would sit for hours with the sunlight
streaming in the high windows and know
the delivery van was safe, locked in the yard
with the brewery trucks, and my job secure.
I chose first a virgin copy of *The Idiot*
by Dostoyevsky, every page of which confirmed
life was irrational. The librarian, a woman
gone gray though young, sat by the phone
that never rang, assembling the frown
reserved exclusively for me when I entered
at 10 A.M. to stay until the light dwindled
into afternoon. No doubt her job was to guard
these treasures, for Melville was here, Balzac,
Walt Whitman, my old hero, in multiple copies
each with the aura of used tea bags. In late August
of 1951 a suited gentleman reader creaked
across the polished oaken floor to request
the newest copy of *Jane's Fighting Ships*
only to be told, "This, sir, is literature!"
in a voice of pure malice. I looked up
from the text swimming before me in hopes
of exchanging a first smile; she'd gone back

to her patient vigil over the dead black phone.
Outside I could almost hear the world, trucks
maneuvering the loading docks or clogging
the avenues and grassy boulevards of Detroit.
Other men, my former schoolmates, were off
on a distant continent in full retreat, their commands
and groans barely a whisper across the vastness
of an ocean and a mountain range. In the garden
I'd planted years before behind the old house
I'd long ago deserted, the long winter was over;
the roses exploded into smog, the African vine
stolen from the zoo strangled the tiny violets
I'd nursed each spring, the mock orange snowed
down and bore nothing, its heavy odor sham.
"Not for heaven or earth would I trade my soul,
rather would I lie down to sleep among the dead,"
Prince Myshkin mumbled on page 437,
a pure broth of madness, perhaps my part,
the sole oracular part in the final act
of the worst play ever written. I knew then
that soon I would rise up and leave the book
to go back to the great black van waiting
patiently for its load of beer kegs, sea trunks
and leather suitcases bound for the voyages
I'd never take, but first there was *War and Peace*,
there were Cossacks riding their ponies
toward a horizon of pure blood, there was Anna,
her loves and her deaths, there was Turgenev
with his impossible, histrionic squabbles,
Chekhov coughing into his final tales. The trunks—
with their childish stickers—could wait, the beer
could sit for ages in the boiling van slowly
morphing into shampoo. In the offices and shops,
out on the streets, men and women could curse
the vicious air, they could buy and sell
each other, they could beg for a cup of soup,
a sandwich and tea, some few could face life
with or without beer, they could embrace or die,
it mattered not at all to me, I had work to do.

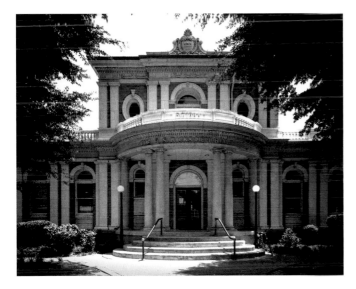 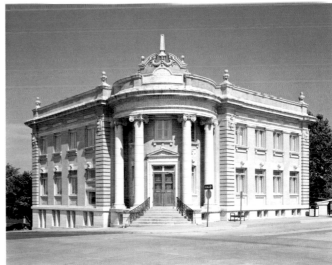

opposite
Old and new libraries, Cossitt Branch Library, Memphis, Tennessee, 2011 | Located on a bluff overlooking the Mississippi River, this first public library in Memphis opened in 1893. The library was built in a beautiful Romanesque style, with rounded wings, towering turrets, and graceful gables. Unfortunately, a controversial reconstruction in 1959 replaced most of the original library. Part of the original red sandstone structure still exists today. A plaque inside the library designating it a literary landmark reads:

> *In the 1920s Richard Wright (1908–60) was denied access to the library because of his race. A sympathetic white man helped Wright use the library by secretly lending him his library card, thus nourishing Wright's dream of becoming a writer. This story is told in Wright's famous autobiography,* Black Boy.

The American Library Association designated the Cossitt Branch Library a Literary Landmark in 1998.

left
B. S. Ricks Memorial Library, Yazoo City, Mississippi, 2011 | Founded in 1838, this library was designated a Literary Landmark in recognition of Willie Morris (1934–99), a journalist, editor, author, and renowned Mississippian.

right
Hannibal Free Public Library, Hannibal, Missouri, 2012 | This town was once the boyhood home of the celebrated writer Samuel Clemens, commonly known as Mark Twain. It is also the setting of his books *The Adventures of Tom Sawyer* and *Adventures of Huckleberry Finn*. This beautiful library was the first free public library established in the state of Missouri.

left

Moby Dick statue *The Whaleman* by Bela Lyon Pratt, New Bedford Free Public Library, New Bedford, Massachusetts, 1994 | New Bedford is nicknamed "The Whaling City" and in the nineteenth century was one of the most important whaling ports in the world. The quote "A dead whale or a stove boat" is from Herman Melville's classic book *Moby-Dick*, which begins partly in New Bedford.

right

Main Library, Newark, New Jersey, 2011 | Newark native Philip Roth wrote in *Goodbye, Columbus* of his protagonist's "deep knowledge of Newark, an attachment so rooted that it could not help but branch out into affection." "That attachment and that affection are as much Mr. Roth's as they are his character's," Mervyn Rothstein noted in the *New York Times*.[24] Roth is considered a local literary hero.

opposite

Civil War mural Lee's *Surrender at Appomattox* by Paul Philippoteaux, Pollard Memorial Library, Lowell, Massachusetts, 2011 | This library contains a stunning collection of artifacts, including a series of murals depicting scenes from the Civil War. Lowell-born writer Jack Kerouac frequently used this library as a youth and later in life, when he returned to Lowell.

LEE'S
SURRENDER

STEINBECK COUNTRY

Anne Lamott

In Salinas, word went out. This is how many tribal stories begin: word goes out to the people of a community that there is a great danger or that a wrong is being committed. This is how I first found out that the governor planned to close the public libraries in Salinas, making it the largest city in the United States to lose its libraries because of budget cuts.

Without getting into any mudslinging about whether or not our leaders are clueless, bullying, nonreading numbskulls, let me just say that when word went out that the three libraries—the John Steinbeck, the Cesar Chavez, and El Gabilan—were scheduled for closing, a whole lot of people rose up as one to say, This does not work for us.

Salinas is one of the poorest communities in the state of California, in one of the richest counties in the country. The city and the surrounding area serve as the setting for so many of Steinbeck's great novels. Think farmworkers, fields of artichokes and garlic, faded stucco houses stained with dirt, tracts of ticky-tacky housing, James Dean's face in *East of Eden*, strawberry fields, and old gas stations.

Now think about closing the libraries there, closing the buildings that hold the town's books, all those stories about people and wisdom and justice and life and silliness and laborers bending low to pick the strawberries. You'd have to be crazy to bring such obvious karmic repercussions down on yourself. So in early April, a group of writers and actors fought back, showing up in Salinas for a twenty-four-hour "emergency read-in."

My sad sixties heart soared like an eagle at contemplating the very name: *emergency read-in*. George W. Bush and John Ashcroft had tried for years to create a country the East German state could only dream about, empowering the government to keep track of the books we checked out or bought, all in the name of national security. But the president and the attorney general hadn't counted on how passionately writers and readers feel about the world, or at any rate, the worlds contained inside the silent spines of books.

We came together because we started out as children who were saved by stories, stories read to us at night when we were little, stories we read by ourselves, in which we could get lost and thereby found. Some of us had grown up to become people with loud voices, which the farmworkers and their children needed. And we were mad. Show a

bunch of writers a sealed library, and they see red. Perhaps we were a little sensitive or overwrought, but in this case we saw a one-way tunnel into the dark. We saw the beginnings of fascism.

A free public library is a revolutionary notion, and when people don't have free access to books, then communities are like radios without batteries. You cut people off from essential sources of information—mythical, practical, linguistic, political—and you break them. You render them helpless in the face of political oppression. We were not going to let this happen.

Writers and actors came from San Francisco and San Jose, from all around. Maxine Hong Kingston came from Oakland. Hector Elizondo drove up from Los Angeles, as did Mike Farrell. The poet José Montoya drove from Sacramento, four hours away. Alisa Valdes-Rodriguez flew all morning to be there. I drove down from the Bay Area with the Buddhist writer and teacher Jack Kornfield.

When we arrived, the lawn outside the Chavez library held only about 150 people—not the throngs we had hoped for—but the community was especially welcoming and grateful, and the women of CODEPINK, who helped organize the event, kept everyone's spirits up. It's hard to be depressed when activists in pink feather boas are kissing you. Many people had pitched tents on one side of the library, where they could rest through the night while the readings were proceeding onstage.

Can you imagine the kind of person who is willing to stay up all night in the cold to keep a few condemned libraries open?

Well, not me, baby.

I was going home to my own bed that night. But then I saw some of my parents' old friends who were planning to stay, people who have been protesting and rallying in civil rights and peace marches since I was a girl, people who had driven from San Francisco because they've always know that the only thing that keeps a democracy functioning is the constant education of its citizens. If you don't have a place where the poor, the marginalized, and the young can find out who they are, then you have no hope of maintaining a free and civilized society.

We were there to celebrate some of the rare intelligence capabilities that our country can actually be proud of—those of librarians. I see them as healers and magicians. Librarians can tease out of inarticulate individuals enough information about what they are after to lead them on the path of connection. They are trail guides through the forest of shelves and aisles—you turn a person loose who has limited skills, and he'll be walloped by the branches. But librarians match up readers with the right books: "Hey, is this one too complicated? They why don't you give this one a try?"

Inside the library were Hispanic children and teenagers and their parents, and a few old souls. They sat in chairs reading, stood surveying the bilingual collection, and worked at the computers. These computers are the only ones that a lot of people in town have access to. The after-school literacy and homework programs at the libraries are among the few safe places where parents can direct their children, away from the gangs.

On this afternoon, parents read to their children in whispered Spanish, and the air felt nutritious. As Barry Lopez once said, "Sometimes a person needs a story more than food to stay alive."

I went back outside. Poets of every color were reading. People milled around with antiwar placards—"¡Libros si! ¡Bombas no!" Older members of the community told stories from legends, history, their own families. Fernando Suarez stepped up to the mike and spoke of his nineteen-year-old son, who had died not long before in Iraq. Suarez spoke first in English and then in Spanish, as he does frequently around the country, and your heart could hardly beat for the sadness.

Maybe in Oaxaca children are still hearing stories that the elders tell, but these kids in Salinas are being raised by television sets: they are latchkey kids. Their parents work for the most part in the fields and in wealthy homes. If you are mesmerized by television stupidity, and don't get to

hear or read stories about your world, you can be fooled into thinking that the world isn't miraculous—and it is.

The media attention brought in enough money, partly as a result of that day, to keep the libraries open for a whole year. You might not call this a miracle, exactly, but if you had been at the emergency read-in, you would see that it was at least the beginning of one.

A bunch of normally self-obsessed artist types came together to say to the people of Salinas: We care about your children, your stories, and your freedom. Something has gone so wrong in this country that needs to be fixed, and we care about that. Reading and books are medicine. Stories are written and told by and for people who have been broken, but who have risen up, or will rise, if attention is paid to them. Those people are you and us. Stories and truth are splints for the soul, and that makes today a sacred gathering. Now we were all saying: Pass it on.

opposite

John Steinbeck Library, Salinas, California, 2009 | The library made national headlines in 2004 and 2005 when all three branches in the struggling farm community of Salinas were slated for closure because of insufficient funding. As discussed in Anne Lamott's essay, in 2005 a nationally covered read-in drew citizens as well as authors to the library to raise awareness about the potential closure. While participating at the nearby Celebrity Golf Tournament in Pebble Beach, actor Bill Murray heard about the crisis. He persuaded some of his fellow celebrities to donate money to the library. The resulting national and global publicity, as well as other private funding, saved the library. Had the branches closed, the hometown of John Steinbeck would have been the largest city in the United States without a library.

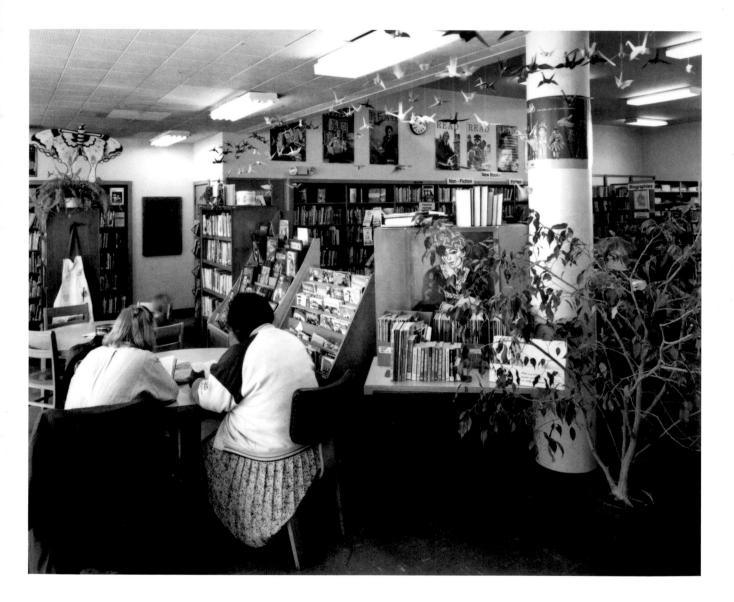

Adult literacy class, Potrero Hill Branch Library,
San Francisco, California, 1994

Knapp Branch Library, Detroit, Michigan, 2011

**Foreign language books, Harold Washington
Library Center, Chicago, Illinois, 2009**

Education in Mississippi by Fred X. Brownstein, Henry M. Seymour Library, Indianola, Mississippi, 2011 | Indianola was home to famed blues musician B. B. King and birthplace of blues player Albert King. It was also the birthplace of the white supremacist group the White Citizens' Council. Its population is currently 75 percent African American with 25 percent living below the poverty line.

left

Lending Library, Occupy Tucson, Armory Park, Tucson, Arizona, 2011

right

Richmond Grows Seed Lending Library, Richmond Public Library, Richmond, California, 2011 | The Richmond Grows Seed Lending Library opened in 2010 and is located at the main public library in Richmond, California. Patrons can "check out" healthy seeds; use them to plant herbs, vegetables, and flowers; and return new seeds from the resulting plants at the end of the season. This seed library is an effort by Richmond residents to grow food locally and build community. Richmond's is the first in the nation to operate from a traditional public library.

opposite

Librarians, Tool-Lending Library, Berkeley Public Library, Berkeley, California, 2011 | The tool-lending library is open to all Berkeley residents and homeowners and currently houses more than twenty-five hundred tools.

Rifle-training class, West Wendover Branch Library, West Wendover, Nevada, 2010 | When I arrived at this desert library, I noticed a sign saying it was closed because of a class being held inside.

I set up my camera outside to take this photograph when the class, a group of children carrying rifles, emerged from the library and formed a line facing West Wendover's casinos and dry, rugged mountains.

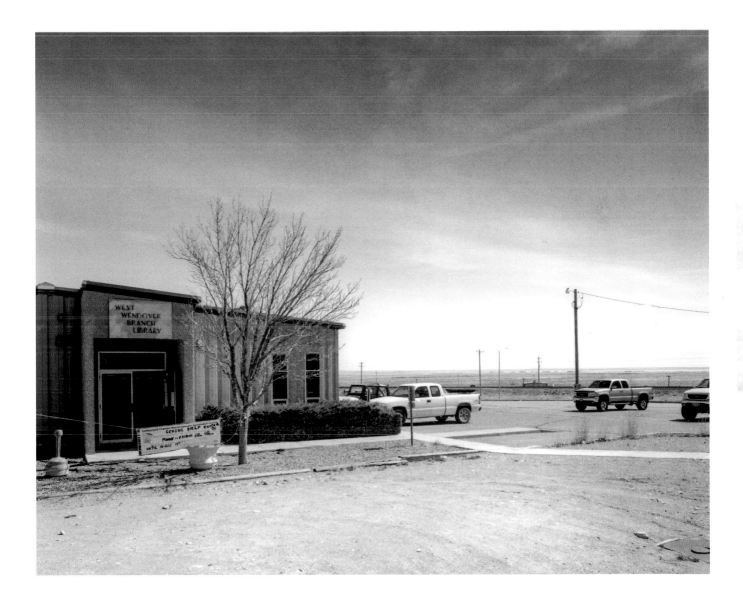

above

Rudy's Library, Monowi, Nebraska, 2012 | The entire population of this town consists of one woman, Elsie Eiler. It is the only incorporated municipality in the United States with such a demographic. She acts as mayor and runs the only business in town, a local roadhouse. Over the years she watched all the other town residents move or pass away. When her husband, Rudy Eiler, died in 2004, she became the town's last resident. Because Rudy had collected so many books, she decided to open Rudy's Library in a small shed next to her home. This memorial to Rudy was free and open to all. Patrons can check out books by signing a notebook. On the day that we photographed, the shed was stifling hot, and sweat poured from our faces and hands. The five-thousand-volume library was filled with old books, magazines, and newspapers. Some of the papers dated back to the 1940s. A wooden sign in the corner simply stated "Rudy's Dream." After I finished I walked into the roadhouse, bought a cold soda, and thanked Elsie for creating such a memorable library.

opposite

Richard F. Boi Memorial Library, First Little Free Library, Hudson, Wisconsin, 2012 | Little Free Library is a community movement in the United States and worldwide started by Todd Boi and now codirected by Rick Brooks. Boi started the idea as a tribute to his mother, who was a book lover and schoolteacher. He mounted a wooden container designed to look like a schoolhouse on a post on his lawn. Library owners can create their own library box, usually about the size of a dollhouse, or purchase one from the movement's website (littlefreelibrary.org). They often have the phrase "Take a Book. Leave a Book." The day I photographed this first Little Free Library, Boi opened its door, and it began to play "The Impossible Dream."

Richard F. Bol Memorial Library
Little Free Library
Last words: "What did the snail say when it rode on the turtle?...Weeee"

Little Free Library

**Walker on Wi-Fi at the Morrill Memorial &
Harris Library, Strafford, Vermont, 2011 |** New
England has a long history of visionary, progressive
thinkers. One of them was the nineteenth-century
US Senator Justin Morrill, who grew up in the
tiny town of Stafford, Vermont. Among his many
accomplishments was starting the system of
land-grant colleges in the United States. When he
was a boy his family was too poor to send him
to college. Later, when he became a senator,
he established these high-quality, low-cost
colleges in each state of the Union. His goal was
to provide free access to information for all who
wanted the chance of improving their lives. The
small Justin Morrill Memorial & Harris Library
in rural Stafford has free Wi-Fi access. Like many
small, rural libraries, this is the only place for
miles around to connect to the Internet. The
library leaves the Wi-Fi on at night, and people
come from all over the area with their laptops. I
photographed Walker in the glow of the computer
screen gaining free access to information in the
darkened library. I imagined that Senator Morrill
would be pleased.

MAPS AND STATS:
DRIVING THROUGH THE COMMONS

Walker Dawson

When I was five, my uncle Bart picked me up after school and blindfolded me. He said, "Let's see if you can give me directions to your home." Blindfolded, I guided him turn by turn for five miles across the city of San Francisco to my home. Bart was impressed, but then, he is a cartographer by profession. And my parents had filled our house with maps, globes, atlases, *National Geographic*s and travel books. Maps and a curiosity about place were in my blood.

I was four years old when my dad started photographing public libraries. He would always bring his large-format view camera along on family road trips throughout California and the West during my early years. My mother and I would walk around a community or wait inside its library exploring new books and magazines while he photographed the building and chatted with the librarian.

As a high-school student I was lucky to have the opportunity to live briefly in Latin America and travel in Europe and Asia. By age sixteen I had seen more of the world than I had seen of my own country. So in the summer of 2011 my dad and I headed out from San Francisco into America on the first of two summer "Library Road Trips,"

logging more than thirty thousand miles. The purpose was to photograph libraries in regions of the United States that he had not yet visited during his eighteen-year project. I saw this as a perfect opportunity to combine my interests in geography, race, history, politics, economics, sociology, and travel.

I researched statistics that I thought would enhance and broaden the scope of the project, such as information about the richest and poorest regions in America, the most literate and illiterate, and those with the highest concentration of specific groups such as American Indians, Latinos, and African Americans. I helped plan the road trips to connect these various ethnic and economic regions of America and to examine them through the lens of statistics and the comparison of their public libraries.

A crucial resource for planning the road trips was the website for the U.S. Census Bureau, which provided information on demographics for every community in America. Statistics such as the racial makeup, the per capita income, the percentage of the population living below the poverty line, and the gain and loss in population over the years provided a fascinating snapshot of each city and town. This

information was incredibly helpful in determining which communities might expand the scope and objectives of the project, even if the libraries themselves were not architecturally or aesthetically interesting. The *New York Times's* interactive "Mapping the 2010 U.S. Census" plots census data visually.[25] However, we could never understand these statistics until we had visited, photographed and engaged with these communities.

Many Internet research tools were critical in planning our itineraries for the library road trips and in guiding us on our day-to-day travels. Google Maps was invaluable for directions, often in very remote areas of the country, and rarely steered us wrong in thirty-thousand miles of travel. Google Maps' street view allowed us to research days in advance which direction a library was facing, which helped us to determine what time of day the lighting would be best to photograph. Google Images allowed us to search using general terms such as "library Kansas City," which would bring up dozens of photos. We were then able to evaluate if a library might be of interest to us architecturally or photographically. Other times I would do a simple web search for "library Iowa," for example, and scroll through pages of random images that the public had uploaded. Flickr .com, a photo-sharing website, was also a great resource for planning.

We began by photographing libraries in Native American pueblos and old Spanish communities, such as El Rito and Santa Fe, New Mexico. We headed south and east along the border between the United States and Mexico to photograph libraries in the two most Latino cities in America, El Paso, Texas (86 percent Latino), and San Antonio, Texas (63 percent Latino). Next we photographed in eastern Oklahoma. This region is inhabited by the descendants of the Cherokee, Choctaw, Chickasaw, and Seminole Indians who were forcibly removed from their ancestral homelands east of the Mississippi and driven along the Trail of Tears.

Eventually we reached the Mississippi Delta of Arkansas, Louisiana, and Mississippi. This vast, fertile plain is largely inhabited by African Americans and is one of the poorest places in the United States. With more than 50 percent of the population living in poverty and having a history of segregation, the region also ranks extremely low in literacy and in health. (Around 40 percent of the people living in the Delta are illiterate, and life expectancy is 67 years for men—close to that of Honduras, El Salvador, and Peru.) We saw many libraries in this region that were underfunded, without electricity, or abandoned. Often, when we asked for directions, locals didn't know if their town even had a library.

We then photographed urban libraries in some of the largely African American postindustrial cities of the North and Northeast, such as Detroit (83 percent African American), Baltimore (64 percent), and Cleveland (54 percent). Many of these cities have high unemployment and poverty rates and are some of the most violent cities in America.

In contrast to these large urban areas, we also focused on the mostly white cowboy communities in oil-rich West Texas (home of George W. Bush), the impoverished white communities in the Ozark mountains of Missouri and Arkansas, and the struggling coal mining communities of eastern Kentucky and West Virginia. Our search for rural libraries took us to many counties in central Appalachia, where almost 40 percent of the population lives in poverty and only 50 to 60 percent of the population has a high school diploma—the lowest of any region in our country. In all these communities—urban and rural—libraries act as a refuge, as well as a place of hope and opportunity in a sea of social problems.

In 2012 we decided to further explore the role of public libraries in Native American and rural white communities. We visited the Crow and Northern Cheyenne Indians in eastern Montana and continued down to the Cheyenne River Indian Reservation of South Dakota, where we photographed the Dakota Club Library in the town of Eagle Butte, a Cheyenne town that is struggling with high unemployment (75 percent), high levels of poverty (60 to

70 percent), methamphetamine addiction, and alcoholism. The local library provides only one computer with Internet access for a community of 3,300 people. We continued photographing in northern Minnesota and Wisconsin on the Leech Lake, White Earth, and Bad River Reservations, all home to the Ojibwe (Chippewa) people. A week later we photographed the struggling neighborhoods of St. Louis, Missouri, and East St. Louis and Cairo, Illinois. Many of the libraries in St. Louis and East St. Louis were either abandoned or had been reduced to rubble in an empty lot.

At the Pine Ridge Indian Reservation in South Dakota, we struggled to find any libraries on the reservation or in nearby communities; we wanted to see how a community with such high levels of poverty and unemployment was affected by not having access to a public library system. Would such devastating conditions exist today if the reservation had possessed a community resource such as a public library? We ended our trip on Ute and Navajo lands in Colorado, Utah, and Arizona. Photographing libraries became more difficult due to the photography regulations on many of these reservations. On a reservation in southwestern Colorado, my father and I became engaged in an intense discussion with the main tribal elder. After an initially hostile encounter, he granted us permission to photograph their library because he understood from personal experience the value of our project's goal of promoting literacy and education.

We also looked at how demographic shifts have affected community resources. In the past sixty years the United States has experienced a major population shift from rural to urban. The West and the South have seen a massive population boom, and with it many new libraries. Austin, Texas, adds two thousand people to its population every month. In contrast, we photographed in many parts of the country that have experienced a dramatic loss of population, such as the plains of Kansas, Nebraska, and South Dakota and the industrial cities of the North and East, such as Detroit, St. Louis, Cincinnati, Cleveland, and Baltimore. St. Louis recorded one of the sharpest declines in population of any city in America—falling from 856,000 people in 1950 to 319,000 in 2010, a loss of more than half a million people. These dramatic shifts in population—either up or down—affect the tax base and revenue for cities and towns, which eventually affect—either positively or negatively—the funding for infrastructure, community services, and local libraries.

We also used our focus on public libraries to understand the differences and commonalities among ultraliberal and ultraconservative communities across the country. Throughout the project we kept asking ourselves, What do publicly funded libraries look like in places that distrust government? How will free access to information remain free in places that say government should have a less active role in our lives?

As we pulled into our driveway at the end of our second road trip, I thought, What an amazing, complex, messy and fascinating country! I now had a face—many faces—and images—some beautiful and inspiring, some odd and sad—to put to the statistics and data of all my research.

AFTERWORD · ANN PATCHETT

I believe it was the extreme smallness of my childhood library that made my later definition of the word *library* so expansive. Had I grown up down the street from the main branch of the New York Public Library, say, I might have thought that libraries were defined by the size of their lions. If my earliest memories had been tied to Harvard's Widener Library, I could have grown up believing that sweeping murals by John Singer Sargent were baseline, and that anything else would be a disappointment. But I attended a small Catholic girls' school in Nashville, where our library consisted of two rows of bookshelves, one on either side of the short hall between the classrooms and the nuns' dining room. At the end of the bookshelves, Joanne Baily sat at a small table. Mrs. Baily was a mother who volunteered to help children find the book they might not know they were looking for. Once that book was secured, she would take the card from its envelope in the back, carefully print out the child's name, stamp on the return date, and file the card away in a little plastic box. All transactions were official. Mrs. Baily made certain it was so.

Just about the time I read Betty Smith's *A Tree Grows in Brooklyn*, in which the heroine is only ever given one of two books by her inattentive librarian, I advanced to the seventh grade, leaving the convent and traveling across a modest parking lot to the upper school. The library for grades seven through twelve was a big step up from the hallway I had known in grade school. The books were kept in their own small room with eight rows of shelves and two tables for studying. Both of the tables sat directly in front of the circulation desk so that Sister Bonaventure could keep an eye on us. I remember wanting to check out Robert Nathan's *Portrait of Jennie* because it looked romantic, and there at the desk I was denied. I was small for my age, and Sister Bonaventure, taking a long look first at me and then the cover (a painting of a girl, probably Jennie, looking vaguely pensive), deemed the book inappropriate. I went back for another novel, and then another, and every time was instructed to reshelve my selection immediately. After so much defeat, I finally decided that the problem was that Sister Bonaventure did not approve of fiction. Testing my theory, I brought several books of poetry to the desk and sailed right through the checkout. That was how I came to start reading T. S. Eliot and W. B. Yeats and Sylvia Plath in seventh grade.

So while I went on in life to be deeply impressed by the Philadelphia Free Library and the Los Angeles County Public Library and our own stunning and still relatively new Nashville Public Library, my idea of what a library is remains the same: a collection of books, however many or few, that are loaned out and gathered back by a professional. After all, libraries have always been defined more by their spirit than by their space. Even the smallest can provide that deep human comfort that comes from reading and ideas. When I think of the rooftop garden of native plants crowning the public library in Salt Lake City, Utah, or the staggering vista offered to readers in Basalt, Colorado, or all the art and innovation that has made the Seattle Public Library the number one tourist attraction in the city, I think, How wonderful. What a gift. But I never think that it is by these luxuries that the library itself is defined.

The definition for me is still the books, and these days that includes just about any book you might be looking for. With the advent of the interlibrary loan system, the one-room structure in rural Kansas is as rich in books as the aforementioned Widener. If the book you need isn't there, your librarian can get it for you. Even with all the cutting of budgets and hours, a library is still the best example of our government at work. We may never have full equality in our legal system, our schools, or our health care, but in our libraries there is parity: all are welcome, all books are free, and, if you can wait a little while, all books are available.

Of course, my book-centric view of libraries could easily be seen as dated. Even though in a recent survey conducted by the Nashville Public Library system patrons listed books as the number one reason for visiting, libraries have considerably more than books to manage these days. So why, when underfunded and oversubscribed libraries are also serving as centers of information and technology,

places from which to conduct job searches, senior centers, homeless shelters, classrooms for reading and language instruction, and teen centers, is there so much speculation that they've become irrelevant? All I can say is that this notion must have been introduced on a slow news day. In May of 1897 Mark Twain wrote a note to a friend that has long been misquoted. The original read, "James Ross Clemens, a cousin of mine, was seriously ill two or three weeks ago in London, but is well now. The report of my illness grew out of his illness; the report of my death was an exaggeration."

Like James Ross Clemens, the book industry did endure a serious illness. The advent of ebooks caused a great deal of panic, and for a time it was feared that books as we knew them were doomed. But books, ever tenacious, have made a strong recovery. I can say this with some authority because I own a bookstore. It is my belief that the illness in the publishing industry brought about the speculation that libraries were on their last leg. Libraries, like Twain himself, had never been sick in the first place, and to speak of their death was flatly ridiculous. Still, it's a terrible job to get people to stop repeating what they think they know.

So know this—if you love your library, use your library. Support libraries in your words and deeds. If you are fortunate enough to be able to buy your books, and you have your own computer with which to conduct research, and you're not in search of a story hour for your children, then don't forget about the members of your community who are like you but perhaps lack your resources—the ones who love to read, who long to learn, who need a place to go and sit and think. Make sure that in your good fortune you remember to support their quest for a better life. That's what a library promises us, after all: a better life. And that's what libraries have delivered.

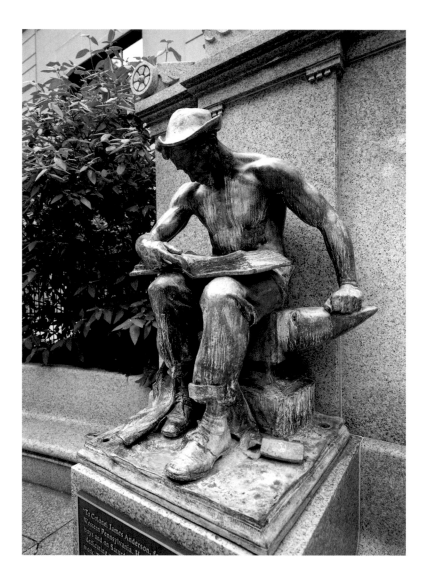

Andrew Carnegie's ideal: statue of a worker with
a book, Allegheny, Pennsylvania, 2011

ACKNOWLEDGMENTS

Thank you! This has truly been a family project. My wife, Ellen Manchester, and our son, Walker, were along for the ride during the many years of this project. Ellen's love of photography, geography, and history kept me focused when I was distracted by my day jobs and other photographic endeavors. Walker, who saw his father obsessed with libraries for most of his life, grew up to become a major contributor to logistics and planning for the last two years of the library road trips. I know that I am lucky to have such a supportive and enthusiastic family.

I would like to thank all the contributors to this book. Everyone gave so freely of their time and energy to make this idea a reality. I am especially grateful to Bill Moyers and Ann Patchett, who contributed original essays for the foreword and afterword. It has been an inspiration for me to meet and work with such decent and generous people. Not only did they contribute their powerful words, but they also cleared time in their incredibly busy schedules to write them. Such generosity should be an inspiration for us all. I am also indebted to my editors at Princeton Architectural Press, Sara Bader and Sara Stemen. This book would not have been possible without their steady hands and patience.

Thank you to the San Francisco Public Library for presenting an exhibition of the work in 2010 and to Luis Herrera, Marcia Schneider, and Lisa Vestal for their enthusiastic support of the project. The city of Fanoe, Denmark, acquired a set of images from the project and traveled the exhibition to libraries in several cities throughout the country. Thank you to Lars Olsen for seeing the value of the American public library system.

For a good night's sleep in artful surroundings, food and drink, and energetic conversations late into the night—and again over coffee in the early mornings: Ben and Rachael Amber, Virginia and Michael Beahan, the late Michael Black, Greg and Dorothy Conniff, Peter de Lory and Kay Kirkpatrick, Terry and Sam Evans, Dave Freund and Claudia Ciucci, Jeff Gates and Susie Krasnican, Stanley Greenburg and Lynn Yellen, Barbara Houghton and Keith Farley, Jacqui Koopman, Leslie and Jacques Leslie, Stephanie Machen, Katie and John Manchester, Phoebe Manchester and Mary Burke, Judith Marvin, Rainer and

Barbara Neumann, Kenda North and Wilson Meador, Meridel Rubenstein, Rob Shaeffer and Margaret Moulton, Rebecca Solnit, JoAnn Verburg and Jim Moore, Jerry West, Martha and Chip Wright, and Terry Young and Kitty Connelly. The late Dorothy Manchester was a great advocate for local public libraries and provided early encouragement for the project. Of course, none of my projects are possible without help from Martha and Bros. coffee.

I am grateful for the early support of many individuals who contributed via our Kickstarter campaign, especially Angela Filo, Charles Hughes, Erika Eve Plummer, Robert Chlebowski and Gray Brechin, Leida Schoggen and the 186 friends and strangers who kicked in gifts from $10 to $1,000. Manjula Martin helped manage the successful campaign.

Nick Neumann produced excellent video interviews and documentation during the 2011 Library Road Trip—during the hottest summer on record!

Wendy Brouws, Mary Virginia Swanson, Lena Tabori, and Deborah Lande provided both friendship and professional advice. Conversations with Verna Curtis and others at the Library of Congress validated the importance of the project.

The project received institutional and foundation support from the Graham Foundation for Advanced Studies in the Fine Arts, the James and Doris McNamara Faculty Fund through the Department of Art and Art History at Stanford University, the Fred Gellert Family Foundation, the San Francisco Public Library, and the Friends of the San Francisco Public Library.

Finally, I would like to acknowledge all public librarians, and in particular, John Ellzey, Yazoo City, Mississippi; Kay Kirkpatrick, Seattle, Washington; Michael Ruffing, Cleveland, Ohio; Anne White, Natchez, Mississippi; Leisah Bluespruce, Eagle Butte, South Dakota; Sally Perry, Pecos, Texas; Julia Selwyn, San Antonio, Texas; Jeanne Salatheiel, Detroit, Michigan; Andrew Shaw, Salt Lake City, Utah; John Trischitti, Midland, Texas; Greg Hager, Evansville, Indiana; Anne Estrada Davis, Gardiner, Maine; Phillip Carter, Clarksdale, Mississippi, and Julia Parks, Tuscarora, Nevada. Each brought his or her library to life in a way that made this a better project. I asked librarians throughout the country to submit essays about their work for this book. A few are featured here, and others will be included on a website developed in conjunction with this publication. I found librarians, faced with the difficult task of running a modern public library, to be professional, courteous, and extremely helpful. In an era of attacks on public employees, I am continually amazed at how the job of a librarian is a difficult balancing act—providing access to information and dealing with social problems while at the same time always encouraging literacy and education. There must be a special place in heaven for librarians.

CONTRIBUTORS

Walker Dawson is a recent graduate of Eugene Lang College The New School for Liberal Arts in New York City, where he majored in Global Studies. He served as an intern for a human-rights lawyer at the United Nations Human Rights Council in Geneva, Switzerland. He has assisted his father, Robert Dawson, on photo projects in many places throughout the world, including Guatemala, Chile, Argentina, Brazil, Iceland, Mexico, and the American West. In 2011 and 2012 he helped research, plan, and navigate the two Library Road Trips that made this book possible.

Luis Herrera is the City Librarian of the San Francisco Public Library. In 2012 he won *Library Journal*'s Librarian of the Year Award. He was appointed by President Barack Obama to serve on the National Museum and Library Services Board. He oversaw the largest capital campaign in the history of the San Francisco Public Library, which helped build or renovate twenty-two branch libraries around the city. He currently serves on the boards of the Latino Community Foundation and Cal Humanities.

Barbara Kingsolver was trained as a biologist before becoming a writer. Her books include poetry, nonfiction, and award-winning novels such as *The Poisonwood Bible*. Her work often focuses on topics such as social justice, biodiversity, and the interaction between humans and their communities and environments. Each of her books published since 1993 has been a *New York Times* Best Seller. Kingsolver has received numerous awards, including the Dayton Literary Peace Prize in 2011 and the National Humanities Medal. She has been nominated for the PEN/Faulkner Award and the Pulitzer Prize.

Anne Lamott is an American novelist and nonfiction writer based in the San Francisco Bay Area. She is also a progressive political activist, public speaker, and writing teacher. Her nonfiction works are largely autobiographical and cover such subjects as alcoholism, single motherhood, depression, and Christianity. Her books include *Operating Instructions: A Journal Of My Son's First Year*, *Plan B: Further Thoughts On Faith*, and *Grace (Eventually): Thoughts on Faith*. She is a past recipient of a Guggenheim Fellowship.

Dorothy Lazard manages the Oakland History Room, a special reference collection of the Oakland Public Library. Before coming to Oakland Public, she worked for many years at the University of California at Berkeley, where she ran two small campus libraries. She holds a master's degree in Library and Information Studies from UC Berkeley and an MFA in Creative Nonfiction from Goucher College in Baltimore. Her writing has appeared in a number of anthologies and magazines, and in the librarians' blog *The Desk Set*.

Philip Levine is a Pulitzer Prize–winning American poet best known for his poems about working-class Detroit. Noted for his interest in the grim reality of blue-collar work and workers, Levine resolved "to find a voice for the voiceless" while working in the auto plants of Detroit during the 1950s. *What Work Is* won the National Book Award in 1991. His next book, *The Simple Truth* (1994), was awarded the Pulitzer Prize for Poetry. He taught for more than thirty years in the English department of California State University, Fresno, and held teaching positions at other universities as well. He was Chair of the Literature Board for the National Endowment for the Arts for 1984–85. He was appointed Poet Laureate of the United States for 2011–12.

David Morris is the author of *The New City-States* and *Neighborhood Power*. He is cofounder of the Institute for Local Self-Reliance and director of the ILSR's Public Good Initiative.

Bill Moyers is an American journalist, social commentator, and philanthropy executive. He was a founding organizer and deputy director of the Peace Corps and served as Special Assistant to President Lyndon B. Johnson for domestic policy and then as White House Press Secretary. After a stint as publisher of the newspaper *Newsday* he became a television analyst, correspondent, and producer for CBS News and PBS. He has received more than thirty-seven Emmy Awards for his investigative documentaries, acclaimed interviews, and pathbreaking series on topics ranging from politics and economics to art, history, and religion. Among his many honorary degrees is one of the first awarded by the American Film Institute. The American Academy of Arts and Letters recognized him for "Distinguished Service to the Arts," and the National Endowment for the Humanities presented him the Charles Frankel Prize (now the National Humanities Medal). Among his other honors are the Nelson Mandela Award for Health and Human Rights, the PEN USA Courageous Advocacy Award, the Lifetime Achievement Award from the National Academy of Television Arts & Sciences, and election to the Television Hall of Fame. His best-selling books include *The Power of Myth* (with Joseph Campbell), *A World of Ideas*, *The Language of Life*, and *Moyers on America*. He is currently the host of the weekly public television broadcast *Moyers & Company*. A former trustee of the Rockefeller Foundation and the Open Society Institute, he is president of the Schumann Media Center, a nonprofit organization devoted to the support of independent journalism.

Stuart A. P. Murray has been an author and editor for almost forty years, specializing in American history. He has written more than fifty books, including the award-winning *America's Song: The Story of "Yankee Doodle"* and *The Library: An Illustrated History*. He has also been a book and newspaper editor, a beat reporter, and a magazine publisher. His journalistic writing has been published in regional dailies as well as in the *New York Times*.

Ann Patchett is the author of six novels, including *Bel Canto* (winner of the PEN/Faulkner Award and the Orange Prize) and *State of Wonder*. She has also written three books of nonfiction, *What now?*, *Truth & Beauty*, and *This Is the Story of a Happy Marriage*. She lives in Nashville, Tennessee, where she is co-owner of Parnassus Books.

Kelvin K. Selders was born in 1957. He has been a paper-boy, farmhand, U.S. Army mechanic, Dodge mechanic, truck stop attendant/labor and training manager, carpenter, tire man/sales and service manager, driver, and, for the last seven years, the Northeastern Nevada Regional Bookmobile Driver for the Elko-Lander-Eureka County Library System. He has an associate's degrees in Mechanics, Networking, and Information from Great Basin College in Elko, Nevada.

Charles Simic is a Serbian American poet, essayist, and translator. He has published more than twenty books of poetry; numerous translations of French, Serbian, Croatian, Macedonian, and Slovenian poetry; books of essays; and a memoir. He received the Pulitzer Prize for Poetry in 1990 for *The World Doesn't End* and was appointed the fifteenth Poet Laureate Consultant in Poetry to the Library of Congress in 2007. He has also been awarded the Frost Medal, the Griffin Poetry Prize, and the Wallace Stevens Award from the Academy of American Poets. Simic is Emeritus Professor of the University of New Hampshire and the Distinguished Poet-in-Residence at New York University.

Amy Tan's novel *The Joy Luck Club* has been translated into thirty-five languages and made into a popular film. She has written several other best-selling novels, including *The Kitchen God's Wife*, *The Bonesetter's Daughter*, and *Saving Fish From Drowning*. In addition Tan has written two children's books: *The Moon Lady* and *Sagwa, the Chinese Siamese Cat*, which was turned into an animated series that aired on PBS. Tan was also in a band with several other well-known writers called the Rock Bottom Remainders.

Chip Ward is a political activist and former grassroots organizer of several successful campaigns to make polluters accountable. He is the author of *Canaries on the Rim* and *Hope's Horizon* and the former assistant director of the Salt Lake City Public Library. Ward writes from Torrey, Utah, a small village that refuses to go big.

NOTES

Introduction

1. Leonard Kniffel, "Reading for Life: Oprah Winfrey," *American Libraries*, May 25, 2011, http://www.americanlibrariesmagazine.org/article/reading-life-oprah-winfrey.

2. Isaac Asimov, *I.Asimov: A Memoir* (New York: Doubleday, 1994), 28.

3. "State of America's Libraries Report 2010," American Libraries Association, http://www.ala.org/news/mediapresscenter/americaslibraries/soal2010; http://www.imls.gov/assets/1/AssetManager/PLS2010.pdf.

4. Bob Herbert, "Losing Our Way," *New York Times*, March 25, 2011.

5. Timothy Egan, "The Great Experiment," *New York Times*, November 8, 2012.

Chapter One: The American Public Library

6. Neil Steinberg, "Libraries look beyond the shelves," *Chicago Sun-Times*, June 3, 2013 http://www.suntimes.com/news/20469729-418/libraries-look-beyond-the-shelves.html.

7. John MacMullen, "A Lecture on the Past, the Present and the Future of the New York Society Library," February 15, 1856, quoted in "About Us," The New York Society Library, http://www.nysoclib.org/about/lecture-past-present-and-future-new-york-society-library.

8. Sir William Berkeley, quoted in "Education in Colonial Virginia: Part III," *William and Mary Quarterly* 6, no. 2 (October 1897): 74.

9. Linda Eastman, "The Library Spirit," *Public Libraries* 4 (October 1899): 343.

10. Andrew Carnegie, *The Gospel of Wealth* (New York: The Century Company, 1901).

11. "Number of Libraries in the United States: ALA Library Fact Sheet 1," American Library Association, http://www.ala.org/tools/libfactsheets/alalibraryfactsheet01.

12. "Public Library Use: ALA Library Fact Sheet 6," American Library Association, http://www.ala.org/tools/libfactsheets/alalibraryfactsheet06.

Chapter Two: Economics

13. Lise Olsen, "Ciudad Juárez passes 2,000 homicides in '09, setting record," *Houston Chronicle*, October 21, 2009, http://www.chron.com/news/nation-world/article/Ciudad-Juarez-passes-2-000-homicides-in-09-1593554.php.

14. Alfredo Corchado, "Families, businesses flee Juárez for U.S. pastures," *Dallas Morning News*, March 7, 2010, http://www.dallasnews.com/news/20100306-Families-businesses-flee-Jurez-for-5693.ece.

15. "Public Library Use: ALA Library Fact Sheet 6," American Library Association, http://www.ala.org/tools/libfactsheets/alalibraryfactsheet06.

16. *Annual Report of the Cleveland Public Library* (Cleveland: Cleveland Public Library, 1931).

17. "The Freedom to Read Statement," American Library Association, adopted June 25, 1953, http://www.ala.org/advocacy/intfreedom/statementspols/freedomreadstatement.

18. "Library of Future: Only 400 Books, Array of Gadgetry," *Washington Post*, November 18, 1979.

19. "The State of America's Libraries: A Report from the American Library Association," American Library Association, http://www.ala.org/news/mediapresscenter/americaslibraries/libraryfunding.

20. Daniel Akst, "Today's Public Libraries: Public Places of Excellence, Education and Innovation," *Carnegie Reporter*, Spring 2012.

21. Alfred Lubrano and Jeff Shields, "Judge Orders Libraries to Stay Open for Now," *Philadelphia Inquirer*, January 6, 2009, http://articles.philly.com/2009-01-06/news/25279958_1_branch-libraries-financial-crisis-emergency-closings.

Chapter Three: Civic Memory and Identity

22. Stuart A. P. Murray, *The Library: An Illustrated History* (New York: Skyhorse, 2009), 255.

Chapter Five: Art and Architecture

23. Mark Twain to the officers of the Millicent Library, February 22, 1894, The Millicent Library, http://millicentlibrary.org/mark-twain-and-henry-huttleston-rogers/.

Chapter Seven: Literature and Learning

24. Mervyn Rothstein, "To Newark, With Love. Philip Roth." *New York Times*, March 29, 1991.

25. "Mapping the 2010 U.S. Census," *New York Times*, http://projects.nytimes.com/census/2010/map.

CREDITS

Grateful acknowledgment of the following for permission to reprint the listed works:

"How Mr. Dewey Decimal Saved My Life," from Barbara Kingsolver, *High Tide in Tucson: Essays from Now or Never*, pp. 46–53. Copyright © 1995 by Barbara Kingsolver. Reprinted by permission of HarperCollins Publishers and Faber and Faber Ltd.

"Steinbeck Country," from Anne Lamott, *Grace (Eventually): Thoughts on Faith*. Copyright © 2007 by Anne Lamott. Used by permission of Riverhead Books, an imprint of Penguin Group (USA) LLC, and The Wylie Agency LLC.

"Library Days," from Philip Levine, *News of the World*, Alfred A. Knopf, 2009. Copyright © by Philip Levine.

Excerpt from "The Boston Athenaeum" from *The Complete Poetical Works of Amy Lowell*. Copyright © 1955 by Houghton Mifflin Harcourt Publishing Company. Copyright © renewed 1983 by Houghton Mifflin Harcourt Publishing Company, Brinton P. Roberts, and G. D'Andelot Belin, Esquire. Reprinted by permission of Houghton Mifflin Harcourt Publishing Company. All rights reserved.

"All Hail the Public Library" Copyright © by David Morris. All Rights Reserved.

"A Country Without Libraries" Copyright © by Charles Simic. Courtesy of *The New York Review of Books*.

"What the Library Means to Me" Copyright © by Amy Tan. First appeared in the *Santa Rosa Press Democrat*. Reprinted by permission of the author and the Sandra Dijkstra Literary Agency.

Letters to the children of Troy, New York. Courtesy of the Troy Public Library.

Robert Dawson's photographs have been recognized by a fellowship from the National Endowment for the Arts and by a Dorothea Lange–Paul Taylor Prize. His books include *Robert Dawson Photographs* (1988); *The Great Central Valley: California's Heartland* (University of California Press, 1993); *Farewell, Promised Land: Waking From the California Dream* (UC Press, 1999); and *A Doubtful River* (University of Nevada Press, 2000). He is founder and codirector of the Water in the West Project. Dawson's photographs are in the collections of the Museum of Modern Art, New York; the National Museum of American Art (Smithsonian Institution); and the Library of Congress. He has been an instructor of photography at San Jose State University since 1986 and at Stanford University since 1996.

Katrina-damaged library, New Orleans, Louisiana, 2008 | When the levees broke during Hurricane Katrina, all of New Orleans's thirteen public libraries were damaged, eight so badly they could not be reopened. More than three hundred thousand books, CDs, and other items were destroyed—nearly half the collection. With the devastation of the city and its government, the New Orleans Public Library was forced to lay off 90 percent of its employees. All libraries were closed for more than two months. The nineteen remaining staff members, when they were able to re-enter the city, began surveying damage and salvaging assets. The destruction was an opportunity to rebuild a better library system.